IMAGES
of America

LOCKPORT
ILLINOIS
THE OLD CANAL TOWN

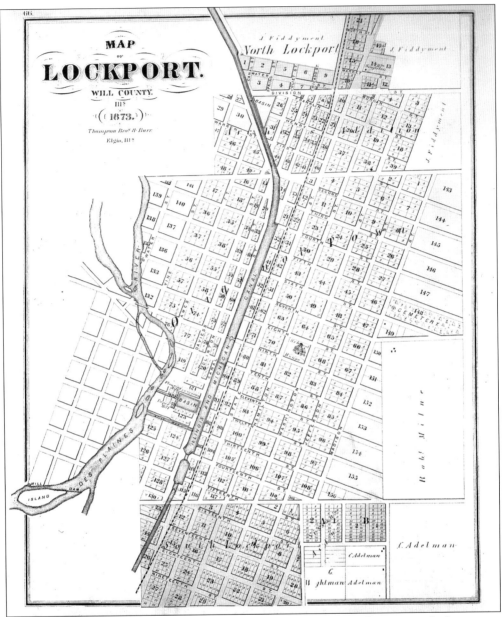

This 1873 map of Lockport was published in the 1873 *Will County Atlas*. It is much the same as the original plat laid out by the Illinois and Michigan Canal Commissioners in 1836 and 1837. The streets were laid out parallel to the canal. Later additions to the town were laid out on the North-South axis.

IMAGES
of America

LOCKPORT
ILLINOIS
THE OLD CANAL TOWN

John Lamb

ARCADIA
PUBLISHING

Published by Arcadia Publishing
Charleston SC, Chicago IL, Portsmouth NH, San Francisco CA

Printed in the United States of America

Library of Congress Catalog Card Number: 2009922879

For all general information contact Arcadia Publishing at:
Telephone 843-853-2070
Fax 843-853-0044
E-mail sales@arcadiapublishing.com
For customer service and orders:
Toll-Free 1-888-313-2665

Visit us on the Internet at www.arcadiapublishing.com

*This book is dedicated to Hazel Cheadle for over a century's
dedication to preserving Lockport's history,
and to my wife, Louise.*

CONTENTS

ACKNOWLEDGMENTS

I would like to thank the following people and institutions who helped directly or indirectly in writing this book. First of all, I'd like to thank Lewis University for its collection of Canal and Regional History in the University Library. In addition, thanks goes to Lockport Main Street, Jerry Adelmann, Elizabeth Anderson, Susan Jackson Keig, Tom Pierson, Hope Rajala, and particularly, Hazel Cheadle, for the assistance in bringing this pictorial material together and for advising me on what it depicts.

Finally, I owe a great debt to the late Bruce Cheadle (1896–1991) for the large gift, both orally and written, on Lockport history that he gave to me and to posterity through the material given to the Canal and Regional History Collection at Lewis University.

INTRODUCTION

Before the first American settler came in the 19th century, Lockport's location in the valley of the Des Plaines River was a ford (later called Butterfield Ford after an early settler). A favorite camping spot for many Native Americans, it formed a natural boundary between the treeless prairie to the west and the moraine that rises to the east of the river bank. Those hills were encumbered with hardwood groves as well as rich prairie. After 1830, this was the first destination of the earliest settlers. They wanted the timber to build their new homes and used the prairie to farm. In 1832, the last Native American outbreak occurred in Illinois, known as Black Hawk's War. Though the Native Americans were friendly to the settlers, a militia force was formed under the command of Capt. Holder Sisson. A blockhouse fort was constructed on the east side of Lockport, and while it never received any hostile fire, it was to be the area's only military fort. After that outbreak, the Native Americans were forced out of Illinois.

The rich prairie sod held great promise of bountiful harvests, but it was difficult to plow or break since the rich soil clung to and clogged the iron plows. In 1833, John Lane, a recent settler, cut up and welded an old steel saw blade acquired from the saw mill at Lockport to make the first steel plow. He continued to make these plows that cut and cleared the prairie sod, until his death in 1857. His plows were made to order on his anvil in the blacksmith shop/farm east of Lockport.

The burgeoning settlement and agricultural production needed to get its produce to market. A canal linking Lake Michigan via the Illinois River to the Mississippi had long been promised. This was the Illinois and Michigan Canal, whose promise goes back to 1673, when Louis Joliet first proposed a waterway for French development of the area. The construction, however, would be a long time coming. When Illinois became a state in 1818, the canal was its first priority. Despite surveys and a federal land grant, little earth was moved. The promise of the canal drew increasing numbers of settlers. In 1830, the Canal Commission laid out the towns of Chicago and Ottawa. Still, the first shovel of earth was not turned until July 4, 1836.

Then the village of Lockport appeared. It was decided by the canal engineer, William Gooding, that this new town would be the Illinois and Michigan Canal headquarters. The first building in the newly platted town was the frame Canal Commissioner's Office erected in 1837. It is now the Will County Historical Society's Canal Museum. In 1838 the Canal Commissioners erected the stone warehouse, now the historic Gaylord building, from stone excavated from the canal bed. It seemed that the town was on its way to become a major manufacturing and transportation center. This was based upon the premise that a deep cut could be made near

Chicago so that the Chicago River would flow backwards down to Lockport, carrying with it an unlimited supply of Lake Michigan water so that Lockport would have an unlimited supply of waterpower. Lockport is the same height above sea level as Lake Michigan and is 40 feet above the nearby town of Joliet.

The bright hope of the new canal was not to be fulfilled right away; the State of Illinois did not have sufficient funds and could only borrow enough to finish the canal in 1848. The "Deep Cut" plan had to be dropped. This failure didn't stop the town's development. When the canal opened in April 1848, the first boat on the canal was built in Lockport and towed to Chicago to officially open the new canal.

If John Lane's steel plow increased agricultural production, it was the new canal that transported the abundant grains to the new markets. It was in Lockport, on the canal, that the new techniques for transporting grain in bulk, and not in sacks, developed. The Norton grain warehouse was built from local stone by Hiram Norton. In this building, the grain was taken from the farmer's wagon and hoisted by belt to various bins from which it would, when the price was right, be loaded into canal boats and shipped to the Chicago market. Thus, the loading technology of that typical mid-western artifact, the grain elevator, was born.

Hiram Norton also built a flour mill, using the canal's waterpower that was located two blocks south of the still standing grain warehouse.

Though Lockport never lived up to the early promise of becoming a major industrial site, it did grow and thrive on the banks of the canal. In 1857, the Chicago and Alton Railroad was built adjacent to the canal as a rival mode of transportation.

As the century turned, the old canal became less important, and a new and much larger one, the Chicago Ship and Sanitary Canal, was built. It terminated at Lockport. This new waterway became more of a boundary than an integral part of the town. It was an engineering feat of considerable importance but not at all a friendly small town canal.

All the various emblems of development such as schools, churches, residences, and farms were part of Lockport's 19th- and 20th-century history. The downtown area, located in the center of Lockport, was created by the canal and served by the later railroad. Its main street, State Street, was the crossroads of life, being a combination of commercial products and cultural diversity. When it was partially destroyed by fire in 1895, it was immediately rebuilt.

The life of this town can also be seen in the pictorial record of a typical family whose founder, Arthur Deeming, worked on the canal as a boat builder, then as a manager of Norton's grain warehouse, and finally, after the Norton enterprise failed, as a newspaperman. The domestic life of this family, traced through three generations, really gives a taste of small town life in the 19th and early 20th centuries.

One

PIONEERS

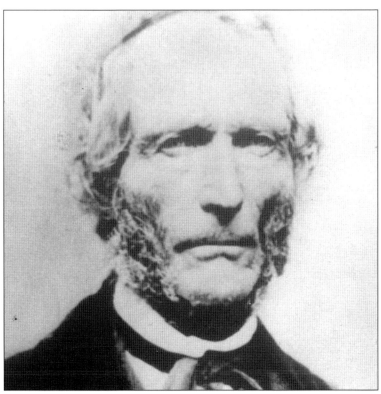

Captain Holder Sisson (1790–1878) was born in Rhode Island and came to Lockport in 1831. In 1832, he commanded the Lockport militia company formed to fight in the Black Hawk War. When rumors of war were first heard, the settlers fled to Fort Dearborn. Those who returned erected a stockade near the junction of Milne Creek and Division Streets. The militia saw no action as the Black Hawk War was more of a Native American scare than an all-out war. Sisson would subsequently move from the east side of the river to the west side, where he built a stone house. The house no longer stands.

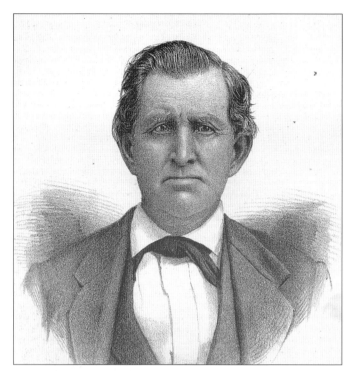

Armstead Runyon (1800–1876) was born in Kentucky and came to Lockport in 1830. He was the first white settler in Lockport Township. In anticipation of the coming of the canal, he laid out a town just north of the present town of Lockport. His hopes for this were doomed when the Canal Commissioners laid out the present town. He did, however, get a contract to work on the Canal Headquarters building, which was built in 1837. When the California Gold Rush occurred in 1849, he headed West. In California, he soon made a handsome living growing fruit.

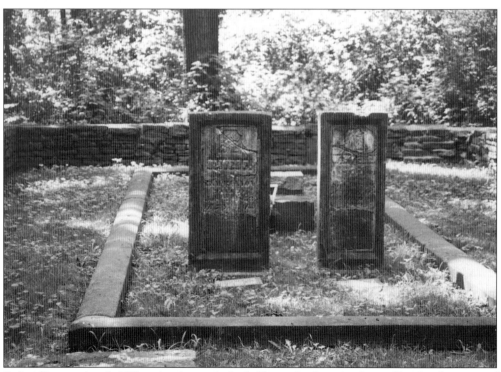

Before Runyon headed West, his first wife died. She and other members of his family, some of whom stayed in Lockport, were buried in this family plot. It is located in the Runyon Forest Preserve of Will County, located in Lockport.

John Lane (1792–1857) came to Lockport from New York in 1832. A blacksmith by trade, he settled in Homer Township east of Lockport in what was called Yankee Settlement. He seems to have immediately set about making a steel plow that would turn the rich prairie soil so the sod would not cling to the plow mold-board as it did to the iron plows then in use. In 1833, he cut a steel saw into strips, and by 1835, he had succeeded in producing the first steel plow. Steel was in short supply and was not produced in this country. Lane continued to produce plows according to each farmer's specifications. He never patented his steel plow; he felt it should be available to every farmer and blacksmith to use as they wished.

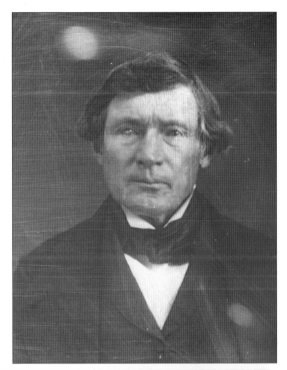

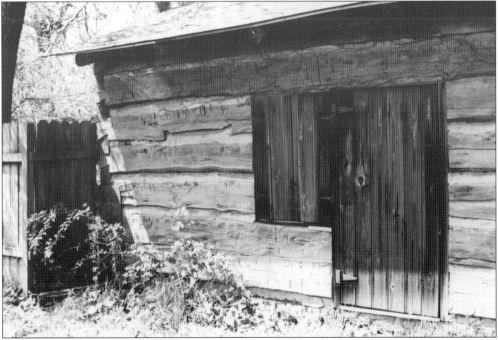

Lane continued to produce his plows on his farm on Gougar Road. He had a factory, but it was a small one. This log building was located on his farm. It was moved to Lockport in the 1930s, by which time it was covered with siding and was somewhat dilapidated. John Lane's son, John Lane Jr., also produced plows of various sorts in his shop, located in Lockport on State Street. He, unlike his father, took out patents for his plows.

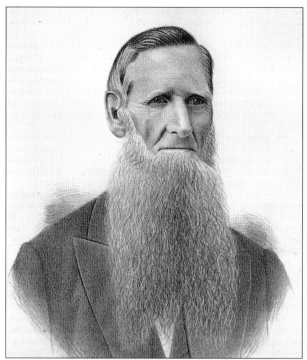

William Gooding (1803–1878) was one of the most important early settlers in Lockport. He came in 1836 to serve as the engineer for the canal. He determined that Lockport should be the canal headquarters because of the potential for waterpower at this site. He felt the future town would be a great manufacturing center. After completing the canal, he became secretary to the Canal Trustees, who he served until 1871, when the canal paid its debts and the State regained complete control of the waterway. He also served as one of the supervisors for the Army Corps of Engineers 1869–1871 survey for the enlargement of the canal. He was appointed surveyor for Oregon, but he turned it down to stay in Lockport.

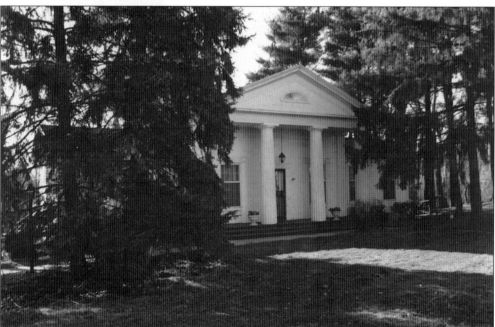

This Greek revival house, originally located on Hamilton Street, was the home of William Gooding. When Gooding lived there, it was the center of the social life of Lockport. Gooding was trained as a canal engineer on the Welland Canal in Canada, the Whitewater Canal in Indiana, and the Ohio and Erie Canal in Ohio. In those days, there were no engineering schools. The trade was learned by apprenticing. Gooding was widely known and respected, and many an important personage of the day visited this house.

Two

CANALS

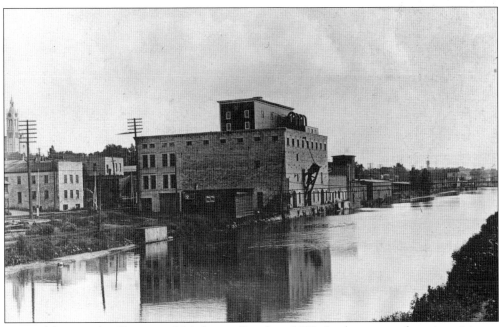

Pictured here is the Illinois and Michigan Canal, c. 1900. Lockport was, from its origins, a canal town. The canal ran 97 miles from Chicago to the Illinois River at LaSalle, Illinois, thus connecting Lake Michigan to the Illinois River. This view looking south from Ninth Street shows the stone building (left) that served as the Hiram Norton grain warehouse. It was built in 1850. The canal in Lockport was 120 feet wide. After flowing through Lock 1, it reverted to its normal width of 60 feet. Its usual depth was 6 feet, but in Lockport it was over 10 feet deep.

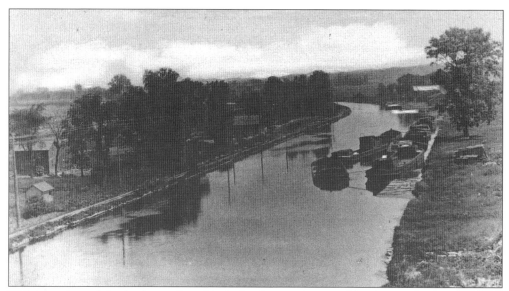

This is a view of the Lockport Boat Yard. As the canal entered Lockport, there was a bend before it widened to 120 feet. The boat yard was located in the area between Second and Fourth Streets. Although there were other boat yards in Lockport, this was the most enduring; it operated until 1906. Originally, canal boats were built here, but when this photograph was taken, it was used only for boat repairs. Canal boats were about 100 feet long and 18 feet wide, the size of the canal lock chambers. After the canal opened in 1848, the boats were hauled by mules that pulled the boat by a tow rope. After 1870, the canal boats were steam powered by a screw propeller.

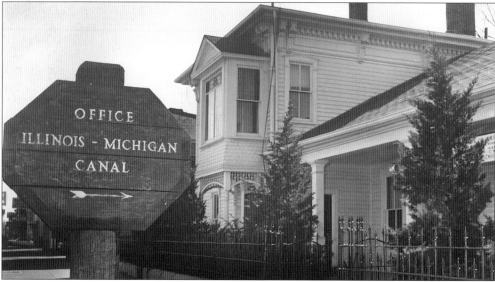

Pictured here is the Illinois and Michigan Canal headquarters building, built in 1837. It is currently the Will County Historical Society's Canal Museum. In 1876, a second story was added on the south end as a residence for the canal superintendent. The original building served as the engineer's office, a land office for the sale of canal lands, and a branch of the Illinois State Bank. It was the first permanent building in Lockport and is the oldest structure on the I and M Canal.

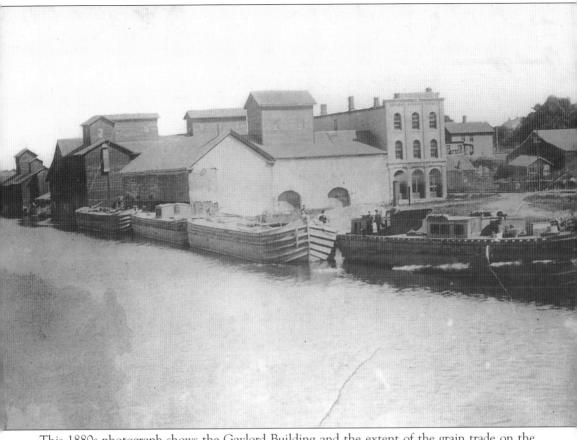

This 1880s photograph shows the Gaylord Building and the extent of the grain trade on the canal. The building in the foreground was built in 1838 with stone from the canal bed. It served as a warehouse for construction equipment needed for the canal contractors. After the canal opened in 1848, it converted to a grainery, and, in the 1850s, the three-story wing was added for use as a store and offices. The four canal boats that are tied up are empty. The building is presently owned by the National Trust for Historic Preservation. It houses a restaurant and gallery.

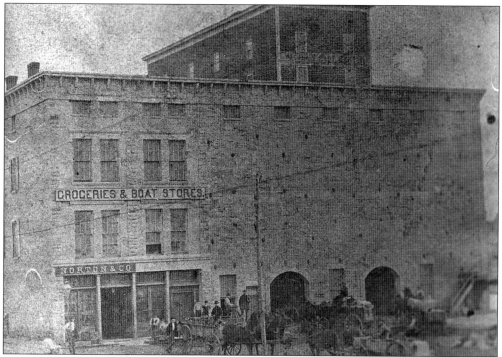

These farmers are unloading grain at the Norton Building, *c.* 1869. The stone building shown here dates from the 1850s and was one of the first buildings designed specifically for transportation of bulk grain. It was built by Hiram Norton, Lockport's leading 19th-century entrepreneur. Farmers brought their grain through the arched doorways, where it was raised to various bins by belts that were driven by the machinery in the wooden structure on the roof. There was also a store and offices on the wing (right). The third floor was used as a dormitory for the Norton canal boat crews. The wing with the arches had only one floor; above it, bins for storing grain were located at various levels. To keep the walls plumb, support rods were anchored by cast-iron brackets on the exterior walls.

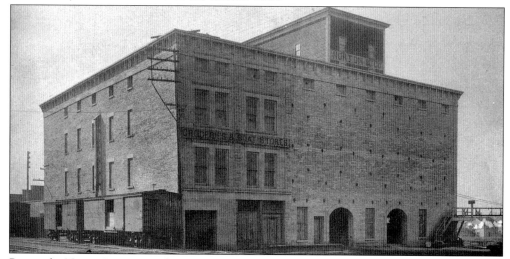

Pictured is Norton's grain warehouse in 1893. By this time, these structures were called elevators. The store had been moved to State Street. Grain was shipped both by railroad and canal boat.

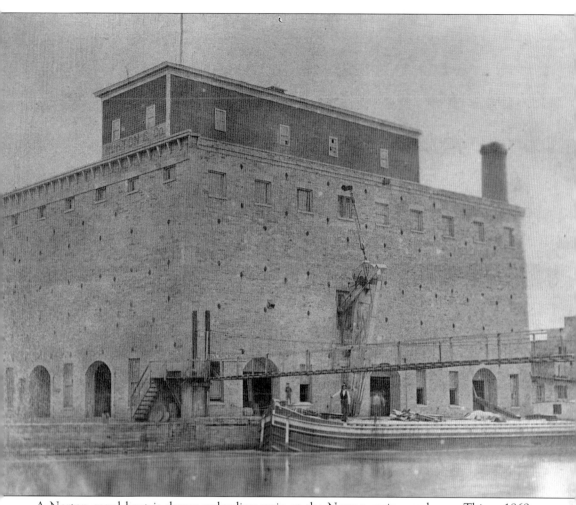

A Norton canal boat is shown unloading grain at the Norton grain warehouse. This *c.* 1869 photo shows one of five canal boats owned by Norton. This type was called a lake boat. The suspension bridge allowed pedestrians to cross the canal here. Occasionally, a pedestrian slipped, perhaps a little woozy from drink, and drowned in the canal.

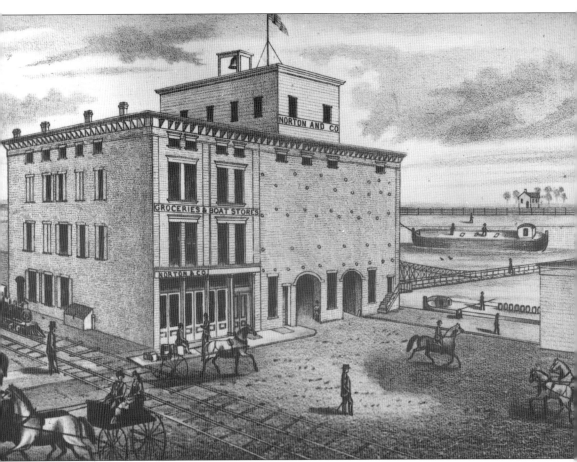

This is an 1873 view of the Norton warehouse from the *Will County Atlas* that was published that year.

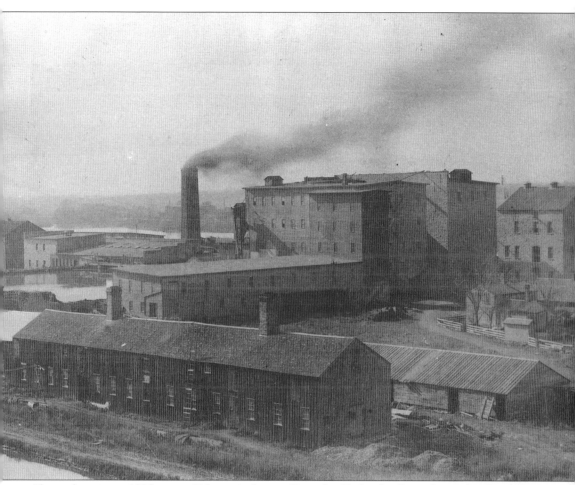

Shown here is an 1893 view of Norton's flour mill on the Hydraulic Basin, located at Twelfth Street. It was designed to take water from the canal and use it to drive water wheels and turbines located 18 feet above the Des Plaines River, into which the water from the spillway flowed. These flour mills were the largest of such operations in the state at the time of the Civil War. On this site, Norton also built a paper mill to make straw board and a cooperage factory. This area was the industrial heart of Lockport.

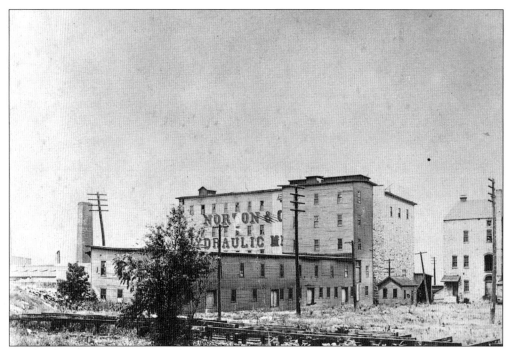

The Hydraulic Basin, shown here *c.* 1912, has been shut down. The buildings deteriorated and the basin was deprived of water and rendered inoperable when the canal was cut by the Calumet Canal to the north.

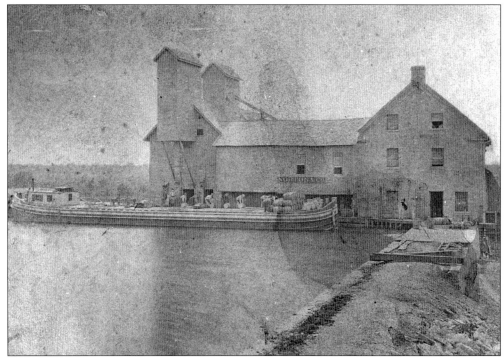

One of Norton's boats loads barrels of flour at the Hydraulic Basin, *c.* 1896. The beam on the right indicates how high the basin had risen above the surrounding land.

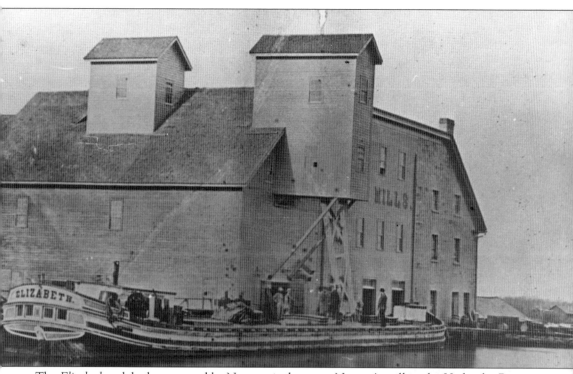

The *Elizabeth*, a lake boat owned by Norton, is shown at Norton's mill in the Hydraulic Basin, c. 1896. The boat was built in 1864.

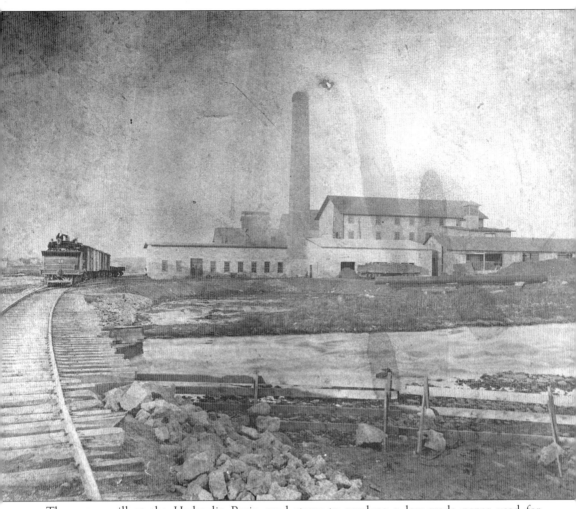

The paper mill at the Hydraulic Basin used straw to produce a low-grade paper used for packing.

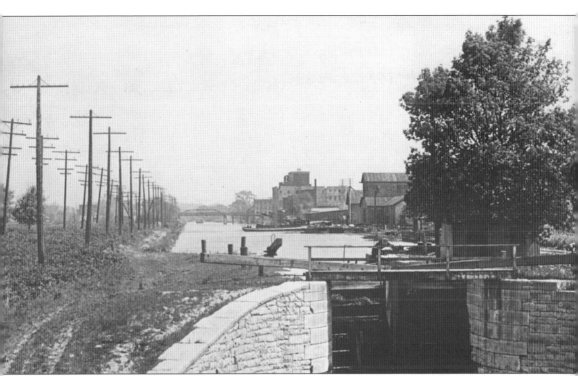

This c. 1901 photo depicts the canal north of Lock 1. The Norton warehouse building can be seen on the right. South of this lock, the canal narrows down to a little over 60 feet wide. The lock lifted boats of lengths up to 10 feet and was one of five such facilities between Lockport and Joliet. The shelter on the right was used by the lock tender when operating the gates. There was also a two-story lock keeper's house located one-half block east of the lock on State Street.

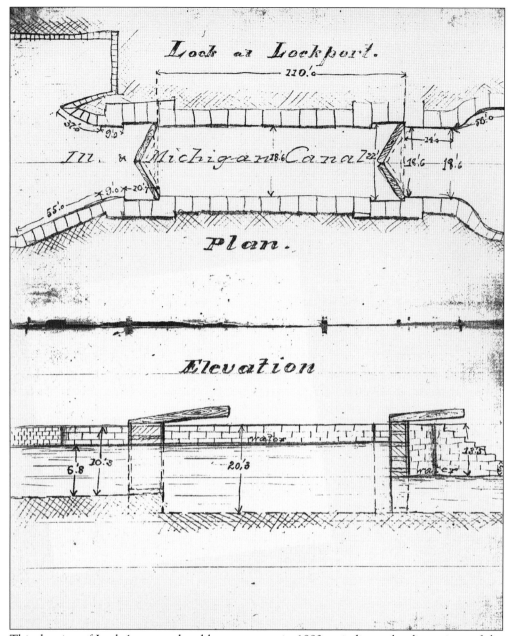

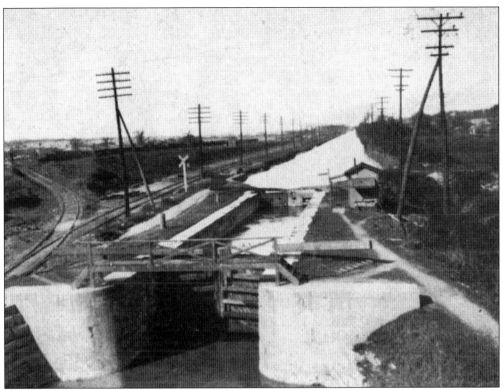

This view of Lock 3, photographed *c.* 1911, is looking north.

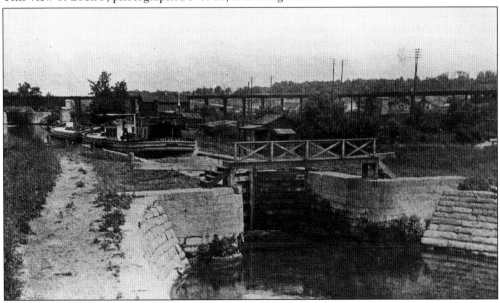

The canal boat *Niagara* is shown between Locks 3 and 4 on the I and M Canal, *c.* 1911. These two locks are located near Joliet. The bridge is for the Elgin, Joliet, and Eastern Railroad. The *Niagara* was a steam-powered canal boat. It made the last commercial cargo trip down the canal in 1914. The steamboats had a pilot house, so they could be navigated on the Illinois River as well as the I and M Canal.

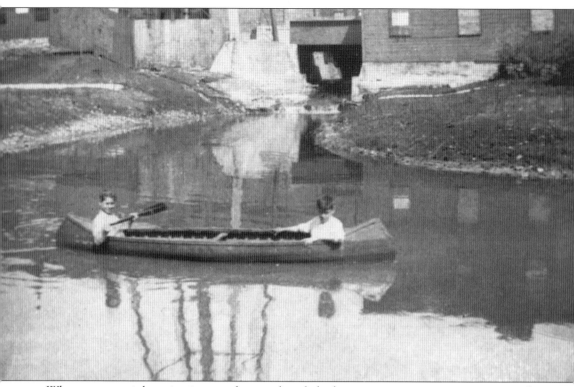

When commercial navigation on the canal ended, there was great interest in using it for recreational purposes. In an effort to use it for that purpose in the 1930s, the Civilian Conservation Corps (a New Deal program to provide employment for young men on public works, particularly for outdoor recreation) made a number of improvements such as canoe landings, bridges, picnic shelters, and trails along the I and M Canal. This 1936 photo of two young canoeists shows where Milne Creek empties into the canal at Eighth Street.

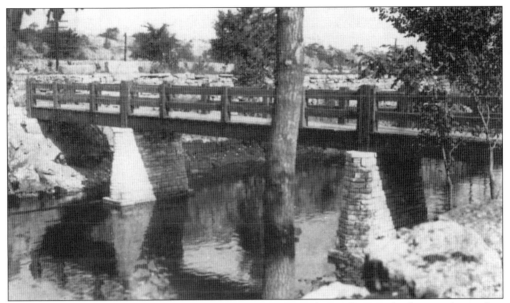

Shown here is the C.C.C. Bridge in Lockport in 1937. This pedestrian bridge was located at Twelfth Street, along with a C.C.C. picnic shelter. The new (current) bridge uses the old abutments; the piers are gone.

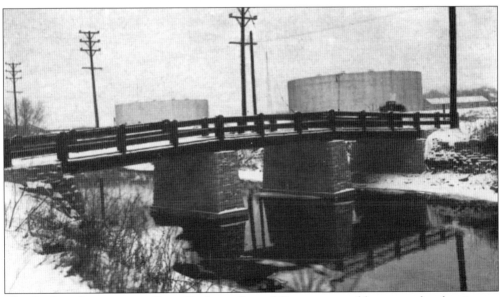

The Civilian Conservation Corps Bridge at Second Street was used by cars and pedestrians to access the Texaco Plant. It no longer exists.

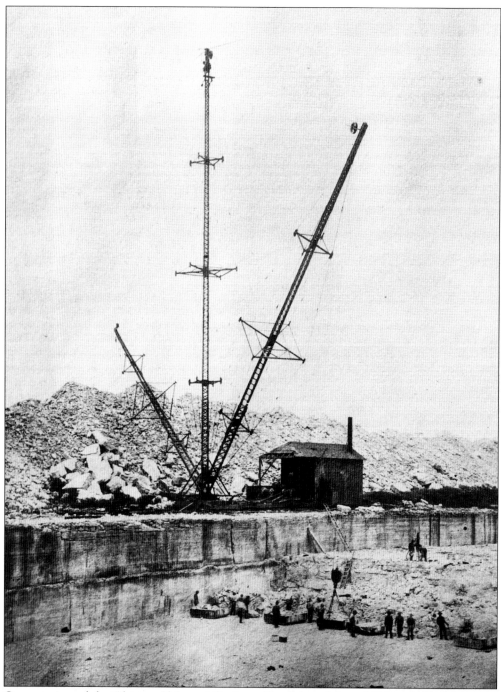

Construction of the Chicago Ship and Sanitary Canal lasted from 1892 to 1900. This 1898 photograph shows some of the unique derricks specifically designed to excavate stone from the canal prism. The canal runs from Chicago to Lockport and was once a major engineering project. In fact, it was the largest canal built in the 19th century. The project required the introduction of all sorts of new construction devices. This was particularly true from Lockport north, where it was necessary to cut through solid limestone to a depth of over 20 feet.

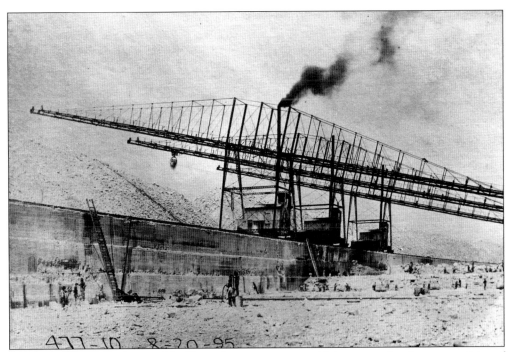

These derricks were designed by Brown's contractors to aid in excavating huge quantities of stone by moving along specially built rails. Sometimes, there were as many as three operating at once (as seen in the photo on page 29). These construction methods were ready made for use in building the Panama Canal a few years later.

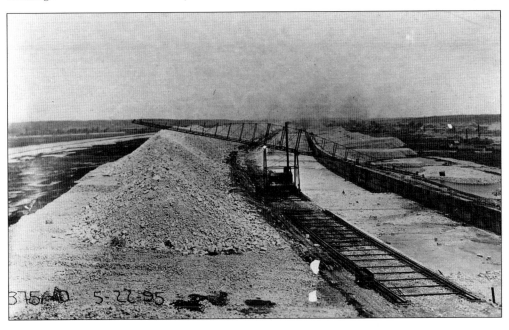

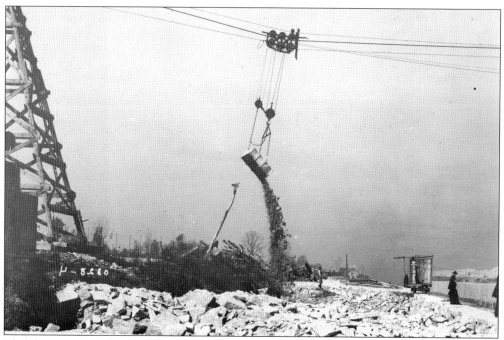

This device was used to haul out smaller stone on the Sanitary and Ship Canal.

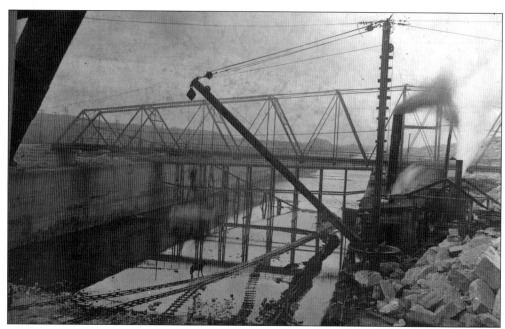

This is the swing bridge that spanned the Ship and Sanitary Canal at Romeo. Even before the canal was finished, the swing bridges that would cross the new canal were being installed. This bridge remained in use until 1990, when it was closed and removed to a nearby bicycle trail.

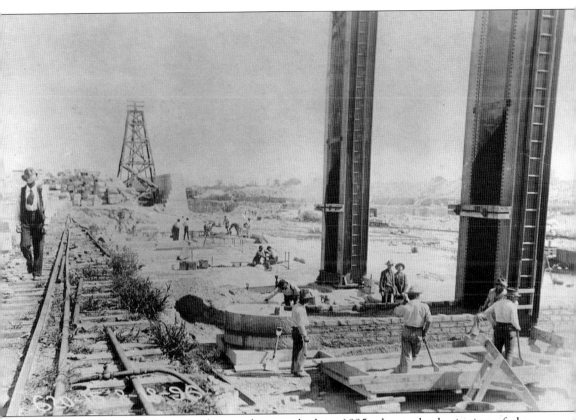

The Controlling Works at Lockport, photographed in 1895, shows the beginning of the construction work. Besides excavating for the canal and constructing bridges at Lockport, the Chicago Sanitary District constructed a huge complex of devices to control the water withdrawn from Lake Michigan. These devices include the Taintor Gates, the only element of this elaborate engineering work still in place and operating.

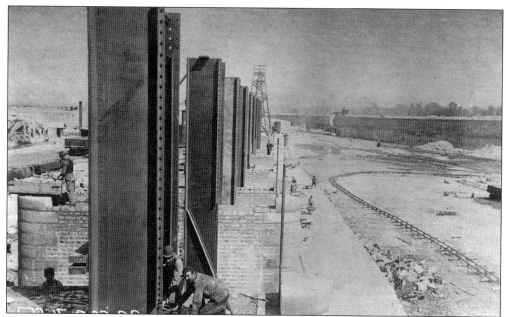

Shown here is a view of the construction of the Taintor Gates. The need for these and the other elements of the controlling works was necessitated by the 18-foot-deep Ship and Sanitary Canal, which enabled water to be drawn off Lake Michigan and flow down to Lockport. If there were no controls constructed at Lockport, Lake Michigan could be drained, dropping 18 feet or more, thus drying up the Niagara River and creating a huge lake over Joliet, 40 feet below Lockport.

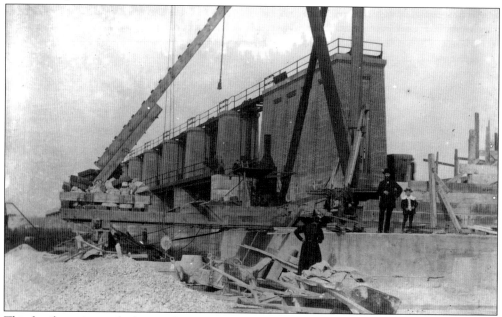

This family outing took place at the construction site in 1897. The gates and other devices were a popular place to visit on Sundays. The livery stables at Lockport advertised the availability of wagons and carriages to travel to the site. Families dressed up and posed for pictures at the construction site.

Here, a couple of tourists visiting the controlling works pose in front of the imposing masonry of the Taintor Gates.

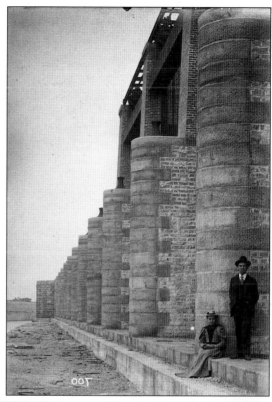

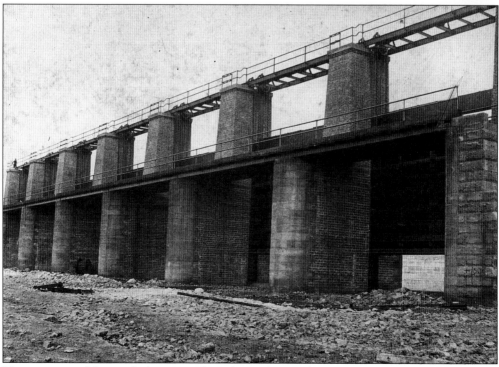

This is a view of the site before water flowed into the canal.

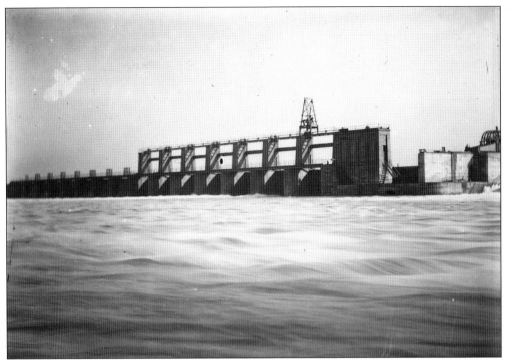

This view shows the site after the canal opened in 1900. Since this engineering marvel was built to pull sewage away from Chicago by reversing the Chicago River and forcing the flow Southwest (so it would be purified by aeration as it flowed to the Mississippi), its opening caused some consternation as far away as St. Louis.

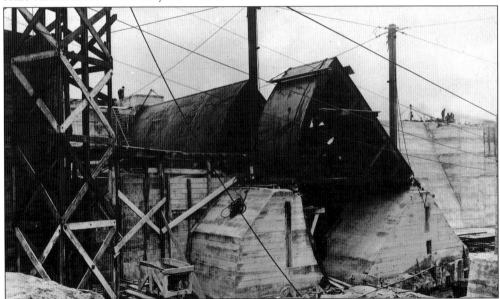

The Great Bear Trap Dam at Lockport was another part of the controlling works. This hydraulic structure was a dam that raised itself as the water level dropped and was lowered when the water level rose. It was designed, as were the Taintor Gates, to divert water in case of heavy rain from the Sanitary and Ship Canal into the Des Plaines River.

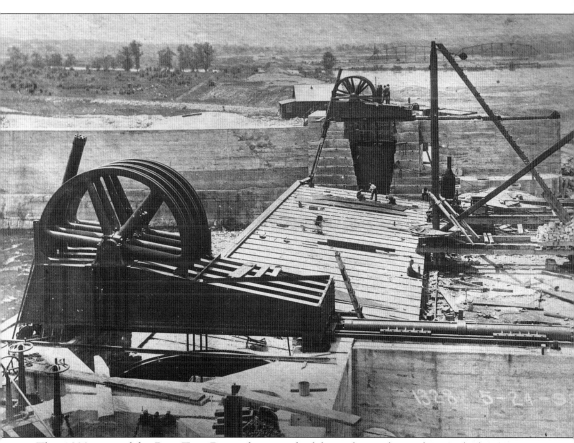

This 1899 view of the Bear Trap Dam, photographed from above, shows the canal when it was nearing completion.

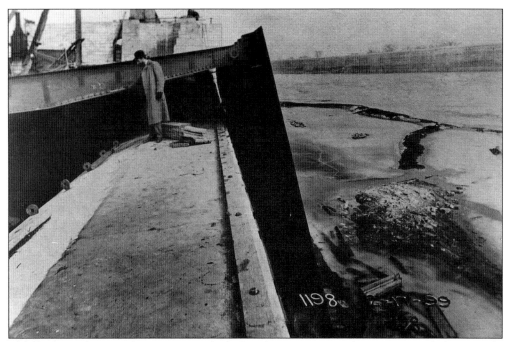

The Bear Trap Dam undergoes inspection before the water enters the Sanitary and Ship Canal.

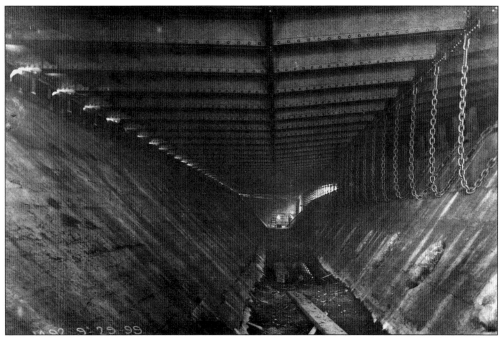

This is the interior of the Bear Trap Dam.

The Bear Trap Dam was in operation in 1900. It is raised because the water level is low.

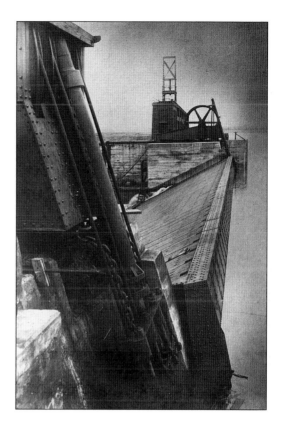

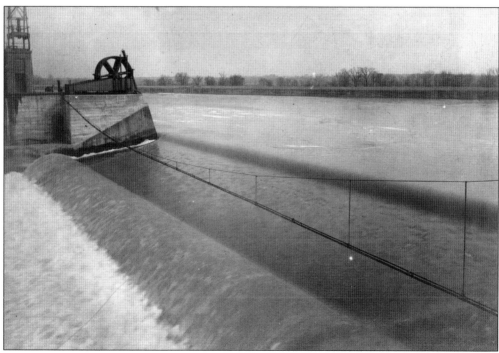

The Bear Trap Dam is lowered and water flows over it into the Des Plaines River.

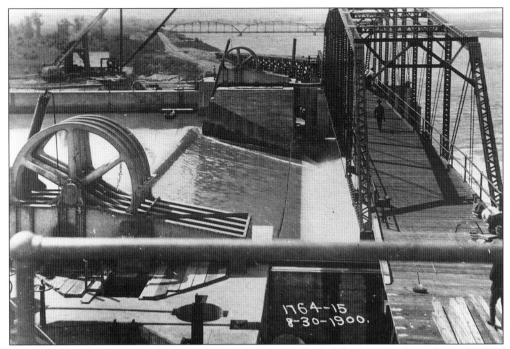

This is a view from the back of the dam in 1900. The body of water on the right is the Des Plaines River, and the bridge across it leads to Lockport. The bridge in the foreground gives access from the controlling works to the Ninth Street Road and the Des Plaines River Bridge.

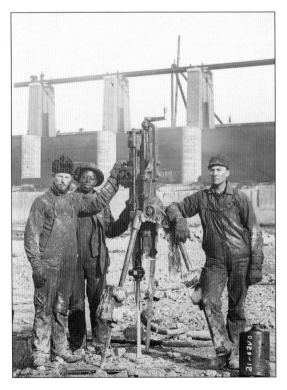

A crew works on the bed of the canal during construction. They are drilling into the limestone so that TNT can be placed in the hole and detonated. This was dangerous work; sometimes the explosive froze during the winter and wouldn't properly explode. Lives and limbs were lost in this process.

A crew is shown working on the stone face of the canal cut. The steam-driven cutter evened off the rock face of the canal prism.

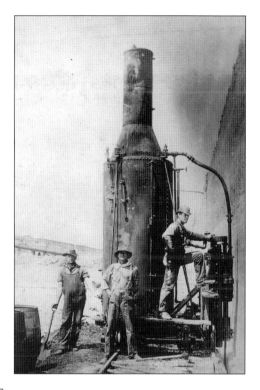

Shown here is the police station at Romeo, located just north of Lockport. There were a number of camps to accommodate the hundreds of workers, most of whom were recent immigrants and African Americans from the South. The camps were rough and the workers could get rowdy, so the Metropolitan Sanitary District had its own police force. This was one of the station houses.

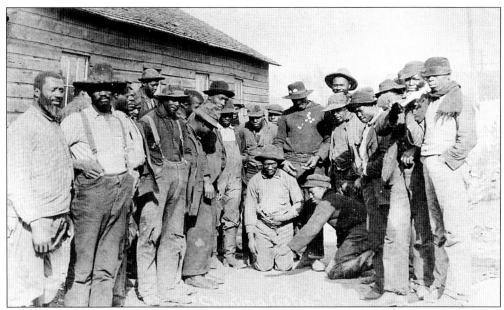

A group of workers is shown in one of the camps, possibly located on the east side of Lockport, where there was a camp of mostly African Americans. The workers were paid $1 a day, the same as workers on the Illinois and Michigan Canal 50 years before.

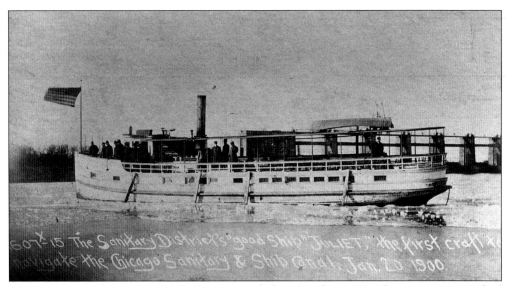

607-15 The Sanitary District's "good ship" JULIET, the first craft to navigate the Chicago Sanitary & Ship Canal, Jan. 2, 1900.

This is a view of the opening of the Sanitary and Ship Canal in 1900. The opening was rushed on January 1, 1900, to preclude a suit filed by the City of St. Louis to prevent Chicago from sending its sewage down to St. Louis. It was called a navigation canal, but it ended at Lockport. There was not an exit until it was extended a mile or more south in 1906. This photo shows where it ended at Lockport. The Taintor Gates can be seen in the background. The good ship *Joliet* reached the end of its voyage at this port.

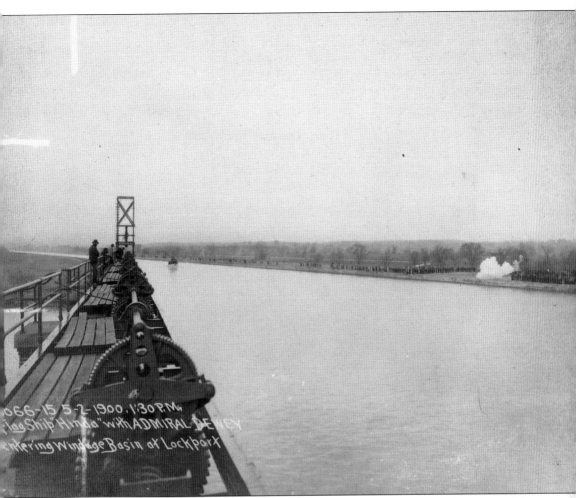

This is a view of the official opening May 2, 1990, when Admiral Dewey embarked on the *Joliet* to sail from Chicago to Lockport. Here, the boat approaches the controlling works at Lockport.

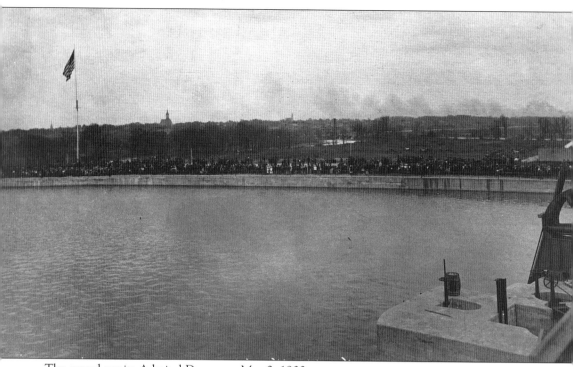

The crowd awaits Admiral Dewey on May 2, 1900.

This is a view from the Des Plaines River of the Bear Trap Dam and the other controlling works in 1903. The only remaining structures are the Taintor Gates. In constructing the canal, the Des Plaines River in Lockport was moved about a mile from its original bed, as depicted on the map of 1873 (page 1). It is now located west of the Sanitary and Ship Canal.

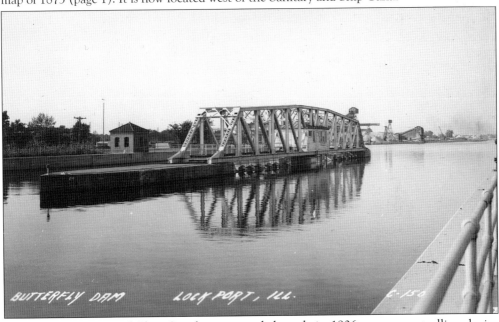

When the Sanitary and Ship Canal was extended south in 1906, a new controlling device was installed and created. This was the unique Butterfly Dam, so called because under water, on this device, were a number of valves that could be opened or closed. Since they moved on horizontal pivots, they were called butterfly valves. The idea was to build a dam that could regulate the flow of water through it by opening or closing the valves. The dam would be kept open except in emergencies, when it would be swung across the canal to stop or regulate the flow of water down the canal, depending on how many of the valves were closed. The structure no longer exists.

The Butterfly Dam, shown here in 1946, is the only known dam of this type.

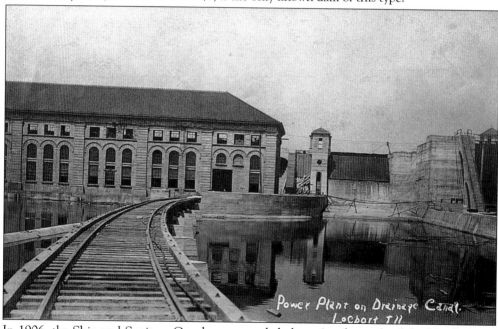

Power Plant on Drainage Canal.
Lockport Ill.

In 1906, the Ship and Sanitary Canal was extended about 1 mile south of the Ninth Street bridge. At that point, besides the hydroelectric plant shown here, there was a lock that could lower boats 40 feet into the Des Plaines River or raise them 40 feet into the Ship and Sanitary Canal to make the canal navigable. The lock was only 20 feet wide and a little over 100 feet long, about the dimensions of an I and M Canal lock. It was a scary experience to be raised or lowered 40 feet in such a narrow space.

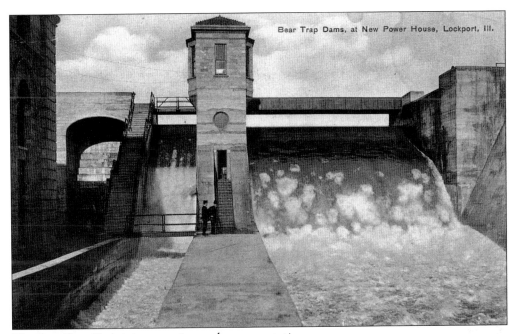

The Bear Trap Dam is in operation at the power station.

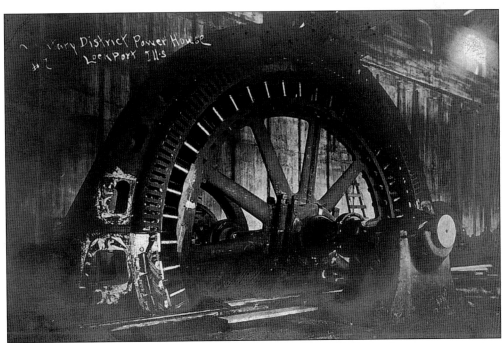

Pictured is a generator inside the Metropolitan Sanitary District's hydroelectric power station. The 40-foot drop from the Ship and Sanitary Canal to the Des Plaines River provided the water power for these generators. The electricity produced was sent to Chicago for lighting in the public parks. The facility still produces electricity, but now it is cycled into the power grid.

The lower gates on the Lockport Lock are being installed. In 1936, the Illinois Waterway was completed, and, as on the much smaller I and M Canal, the first lock was built in Lockport. The artist's rendering shows the lower miter gates of the lock. At the time it was built, it was

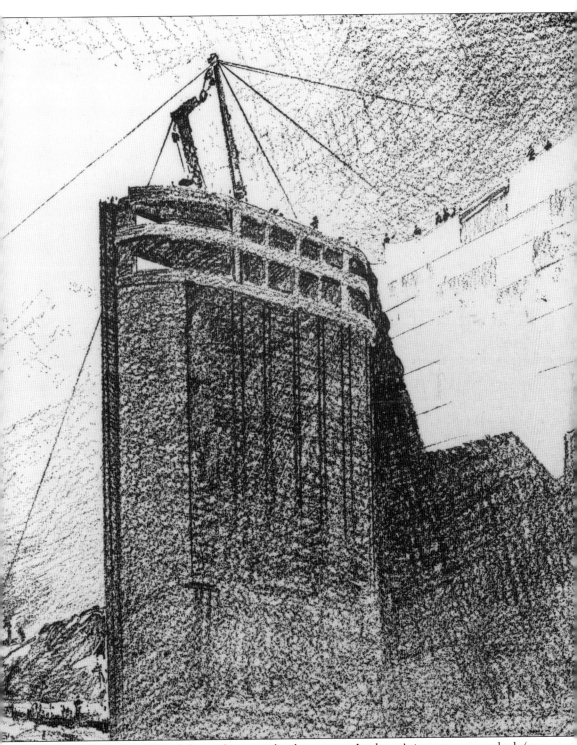

the world's highest lift lock located on an inland waterway. Lockport's importance as a lock (or canal) town was due to the 40-foot drop between Lockport and Joliet—the largest drop on a waterway in the state.

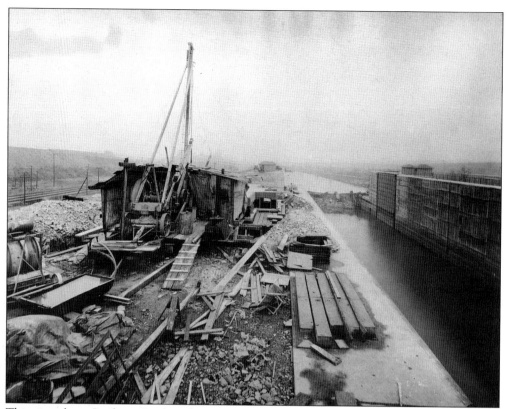

This view shows Lockport Lock under construction.

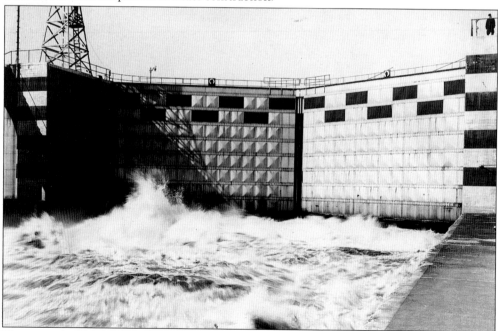

These are the lower gates on the Lockport Lock, photographed in 1945. The miter gates are closed as the lock is being emptied.

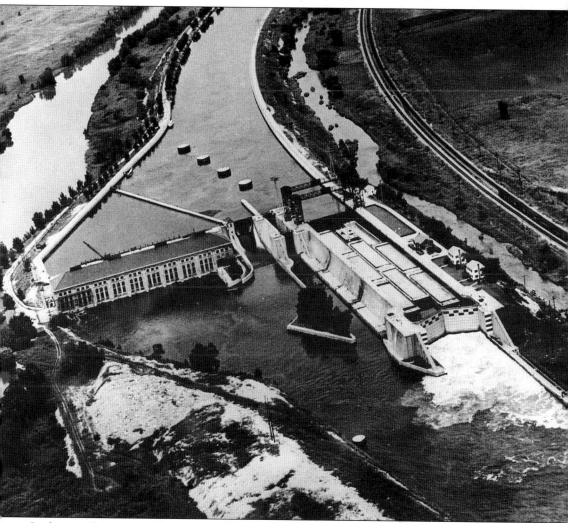

In this aerial view of the Lockport Lock area is the lock that was built in the 1930s. A boat and tow are being lowered into it. To the right is the narrow lock (no longer in use today) built by the Metropolitan Sanitary District in 1906, and to the right of that is the space originally occupied by Bear Trap Dam. When the water flow became controlled by the new lock, the Bear Trap Dam was removed. On the extreme right is the hydroelectric power house still run by the Metropolitan Sanitary District of Chicago, now known as Water Reclamation District of Chicago.

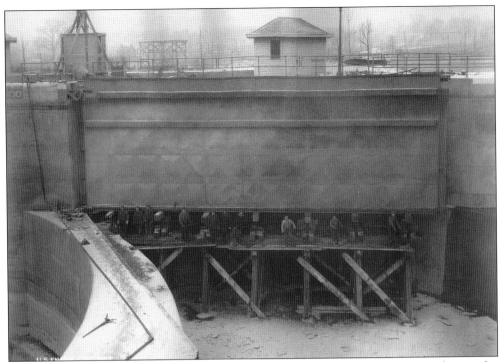

The upper gate on the Lockport Lock is a drop gate that is lowered to let boats in and out and is raised to fill or empty the lock chamber. There is also an emergency drop gate that comes into operation if the principal gate fails. This prevents flooding south of the lock.

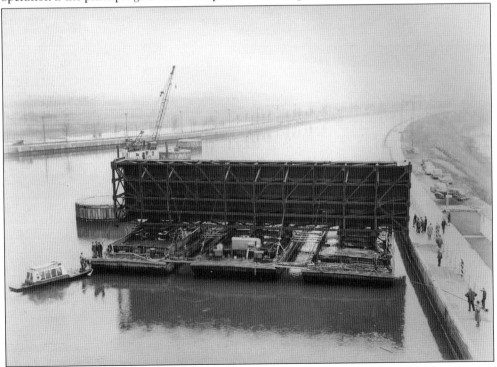

The drop gate is being towed out for repairs in this 1948 view.

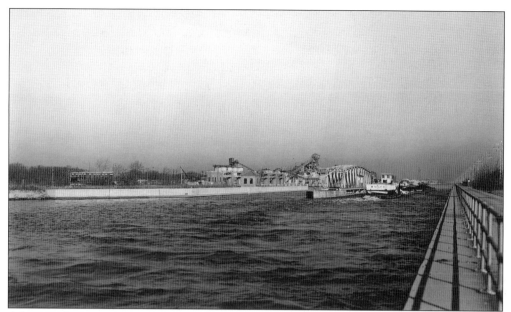

A boat and tow are pictured on the Ship Canal in 1939. The towboat *Betty M.* is shown going past the Butterfly Dam. One of the most interesting tows on the Illinois Waterway happened in 1942, when submarines built in Manitowac, Wisconsin, were towed from Chicago. At Lockport, they were loaded on dry-docks as the depth of the waterway below Lockport was 9 feet, compared to the 18 feet above Lockport. They were towed on dry docks to St. Louis and below on the way to New Orleans for service in the Pacific.

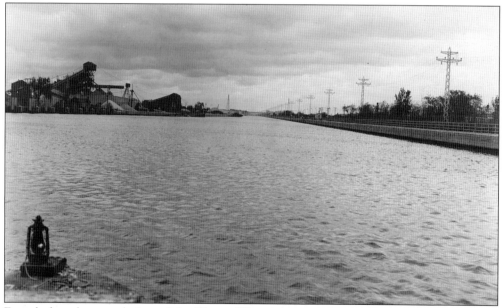

Even before the completion of the Illinois Waterway, numerous industries were locating on its banks. One of these was Material Service, shown here in 1939, in which workers mined for sand and crushed rock for concrete construction. The electric utility poles (right) were erected in 1907 to carry electricity from the hydroelectric power house of the Metropolitan Sanitary District of Chicago.

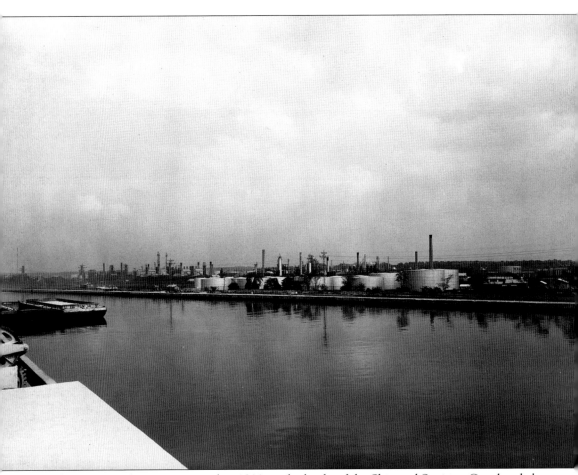

The Texaco refinery was erected in 1911 on the banks of the Ship and Sanitary Canal and also on the I and M Canal. Built to satisfy the increasing demand for gasoline (especially for Chicago-area motorists), it was the Texas company's first refinery in the north. It is now closed.

Three

BRIDGES, ROADS, AND RAILROADS

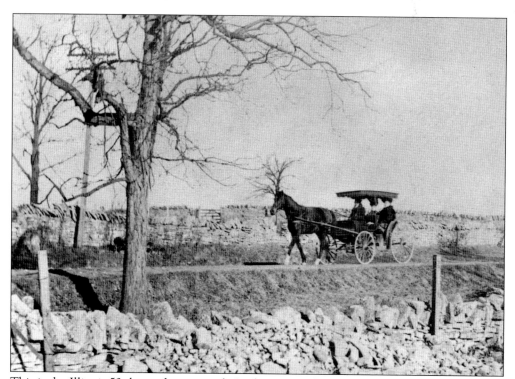

This is the Illinois 53, located just outside Lockport, as it looked in 1890. In the 1930s, Route 66 was built over this old Native American trail. This photograph shows the Fitzpatrick family going to church in Lockport.

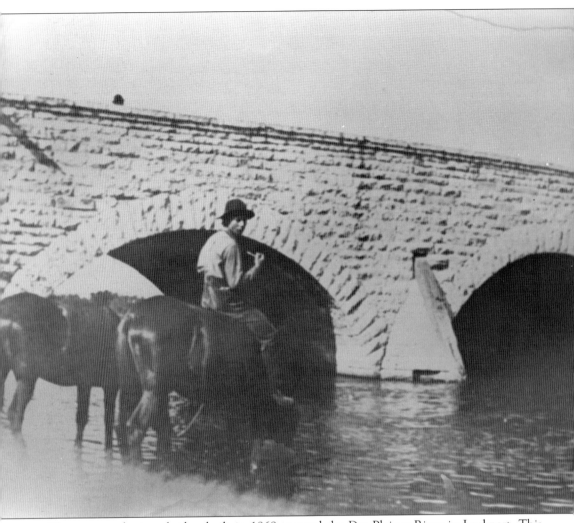

The seven-arch stone bridge, built in 1868, crossed the Des Plaines River in Lockport. This photo of the mule boy watering his charges was made in the 1880s.

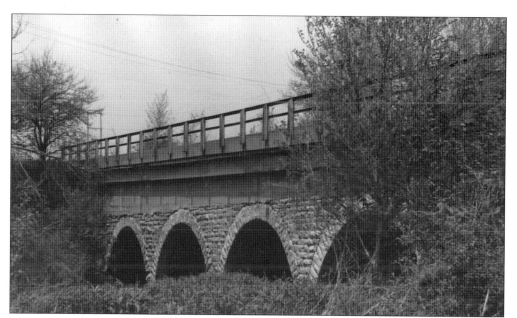

This is a recent view of the seven-arch bridge that crosses Deep Run Creek. When the Ship and Sanitary Canal was built (1892–1900), the Des Plaines Channel was moved west of the Sanitary Canal. The old stone bridge's parapet was torn off and an elevated road was built to cross the swing bridge at Ninth Street.

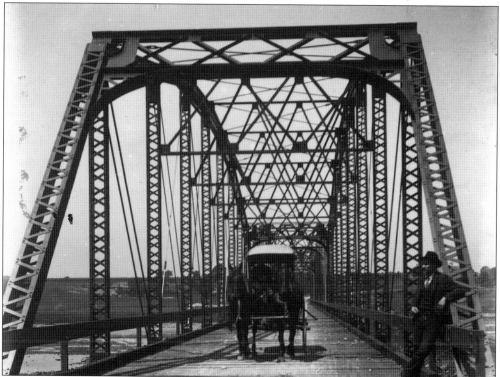

The bridge across the new bed of the Des Plaines River is shown here, c. 1896. After the Des Plaines River was rechanneled west, a new steel-truss bridge was built to cross it.

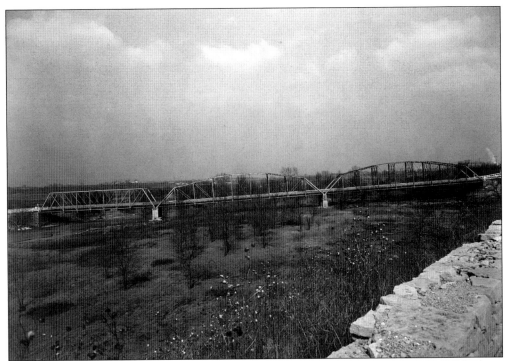

Pictured here in 1948, the Division Street Bridge was located west of town. It was built to cross the new Des Plaines River channel. There are three spans, two are Parker truss and one is a Pratt truss. To the east was a swing bridge that connected that road to Lockport. The truss bridge is still there; it has been made a Will County Historic Landmark. The swing bridge no longer stands.

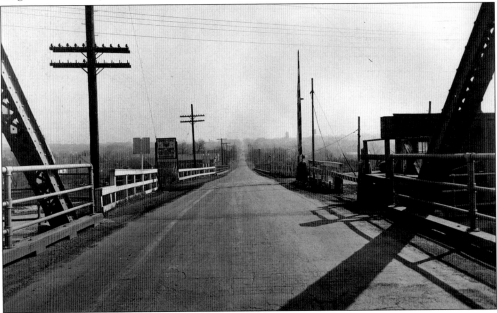

This is a view looking east from the swing bridge across the Ship and Sanitary Canal on Ninth Street in 1944. The old stone bridge is beneath the roadway shown here.

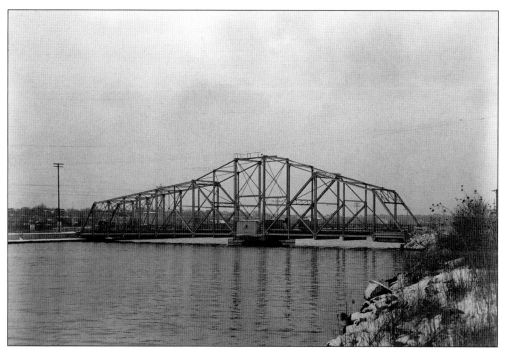

This is a view of the swing bridge at Ninth Street in 1947. At that time, there were three swing bridges in Lockport crossing the Sanitary and Ship Canal; now there are none. This bridge was removed in 1972, when the present high-rise bridge was built. It was a double span truss swing bridge, also called a bobtail swing bridge.

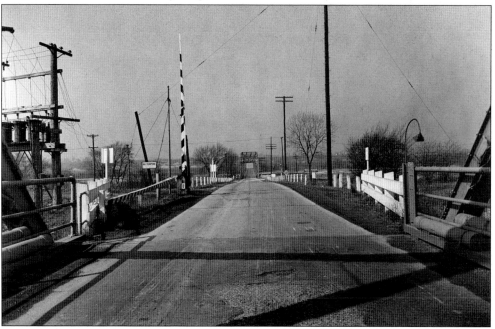

This view is looking west from the Ninth Street swing bridge in 1944. The truss bridge over the Des Plaines River can be seen in the background. This was the second bridge at that site. It was replaced in the 1950s.

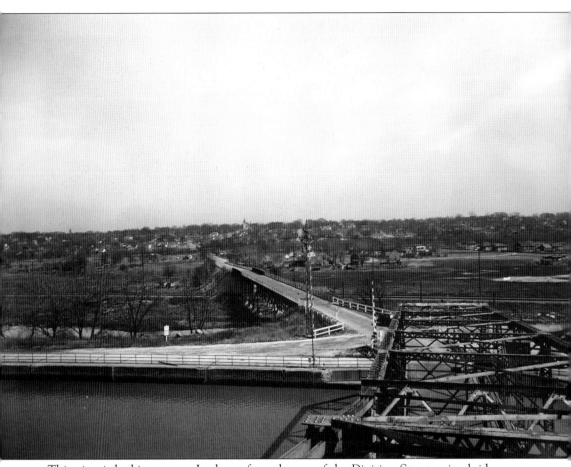

This view is looking east to Lockport from the top of the Division Street swing bridge, across the Ship and Sanitary Canal. This bridge was removed in the 1980s. It was the same design as the Ninth Street swing bridge.

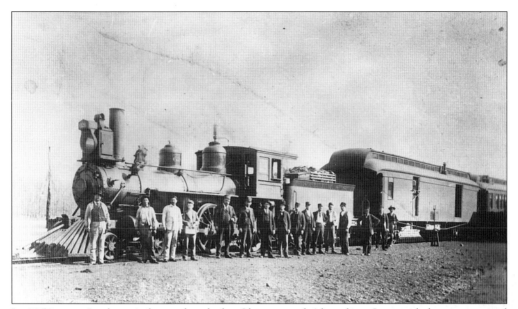

In 1858 came Lockport's first railroad, the Chicago and Alton line. It provided passenger and freight service to Chicago and St. Louis.

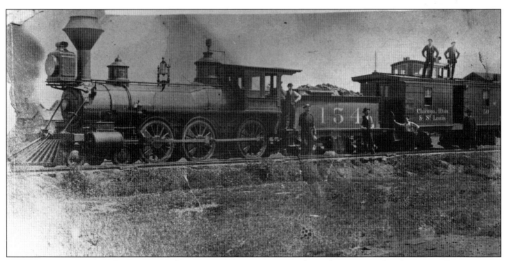

This *c.* 1880 photo shows a freight train in Lockport on the Chicago and Alton, or the C & A, as it was called. In 1872, the railroad laid a double track in Lockport, disrupting the downtown area and reducing Commerce Street to the width of an alley.

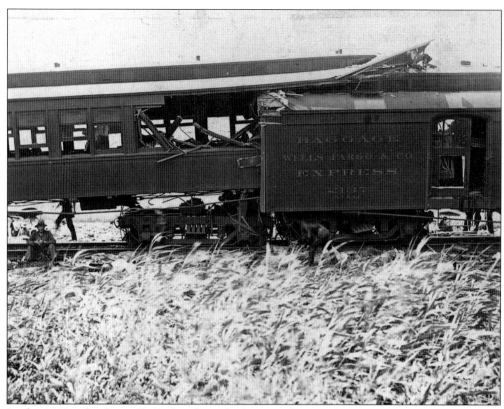

In the 1880s, the Santa Fe Railroad was built in Lockport. This scene shows the wreck of a Santa Fe passenger train just north of Lockport.

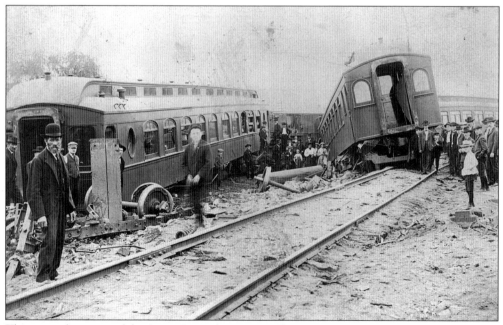

This is another view of the Santa Fe crash in 1900. There were apparently no fatalities.

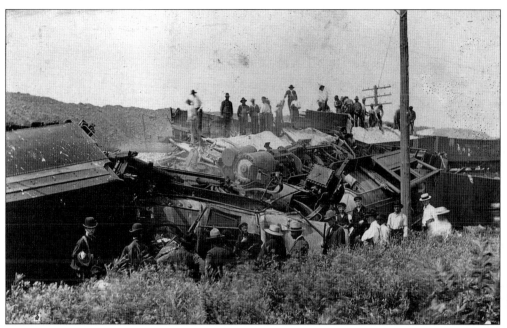

The Santa Fe wreck of 1900 occurred when two passenger trains were derailed. One was believed to be a commuter train traveling between Joliet and Chicago.

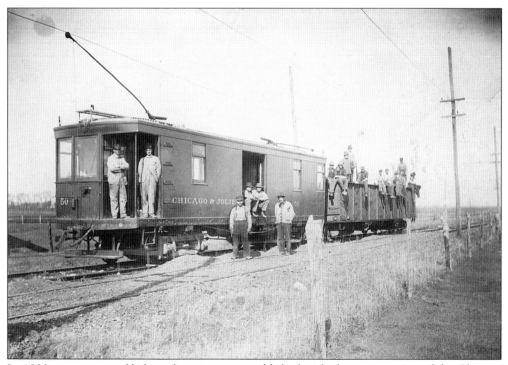

In 1900, a new type of light rail service was established with the construction of the Chicago and Joliet electric interurban. This is a work train outside Lockport.

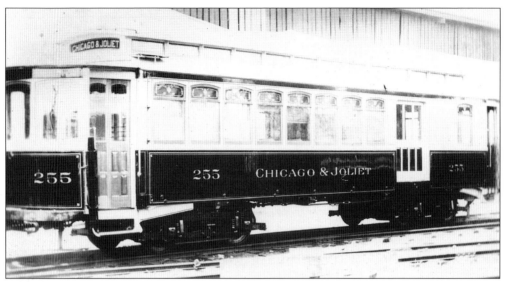

Shown here is a passenger car on the Chicago and Joliet electric interurban. In the early 20th century, there was a rush to generate and distribute electricity. In this area, much of it was generated by waterpower. A dam and generator for this line was built in Joliet on the I and M Canal and the Des Plaines River at Jackson Street. The remains are still visible at the site.

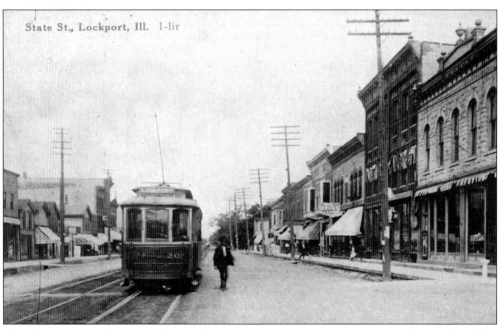

The Chicago and Joliet interurban is shown on State Street in downtown Lockport. This light rail system ran right through town, as its road bed was not as difficult to build as a railroad's.

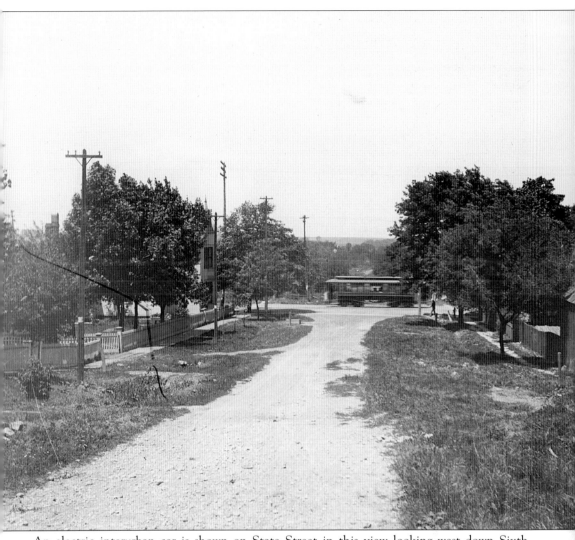

An electric interurban car is shown on State Street in this view looking west down Sixth Street.

Fraction Run Creek is shown here at the present location of Dellwood Park. The creek was dammed to create an amusement park for the Chicago and Joliet interurban in 1906. The interurban system created a number of these encouraging commuters on weekends to take their lines to travel and get out of the city. This photo was taken *c.* 1889.

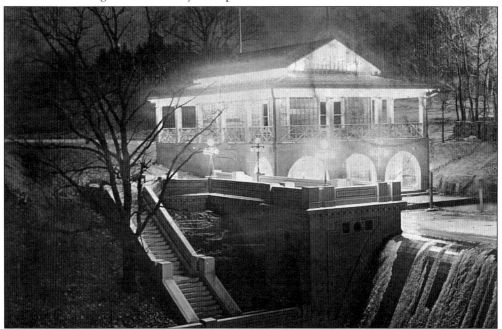

This night view shows the dam on Fraction Run in Dellwood Park and the boathouse. The dam created a little lake for rowing, and the boathouse provided a variety of amusements day and night. Other attractions at Dellwood included a scenic railway and a baseball field. Dellwood was probably the most famous of these interurban amusement parks; it functioned until the late 1920s.

Four

SCHOOLS
AND CHURCHES

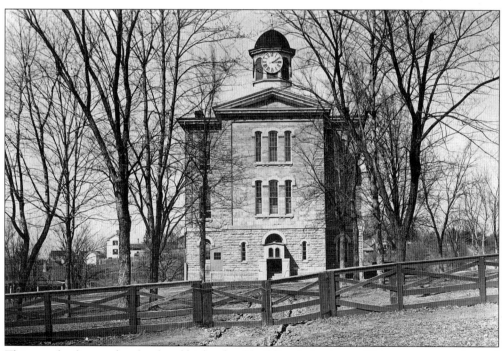

This was the first grade school and high school building in Lockport. This structure was located on the present Central Square. It replaced a frame building just northwest of this building. This three-story stone structure was built in 1857 and was the principal victim of the great Lockport fire of 1895. After that fire, it was replaced by the building now called Central Square.

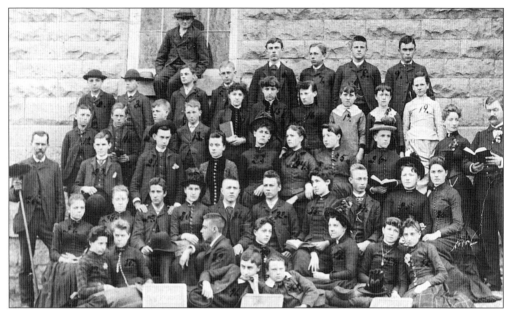

High school students and instructors pose outside the first masonry school building in 1887. The building housed both the grade school and the high school.

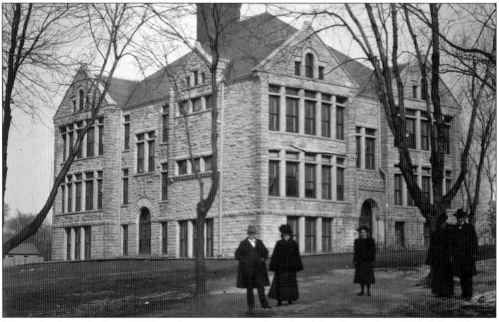

This school was built in 1896 on the same site as the school that burned in 1895. John Barnes, the Joliet architect who designed it, trained in the Richardson Romanesque style, as can be seen in this building. Like its predecessor, it was built of the local dolemitic limestone. This picture was taken c. 1914. In 1910, the high school classes moved to the new high school, and in 1969, the grade school moved to a new building. The block on which these buildings stood was dedicated by the Canal Commissioners as a public square of the town of Lockport in 1837. The city adopted it as the city hall, and it shared the premises with Lockport Township and the Lockport Township Park District.

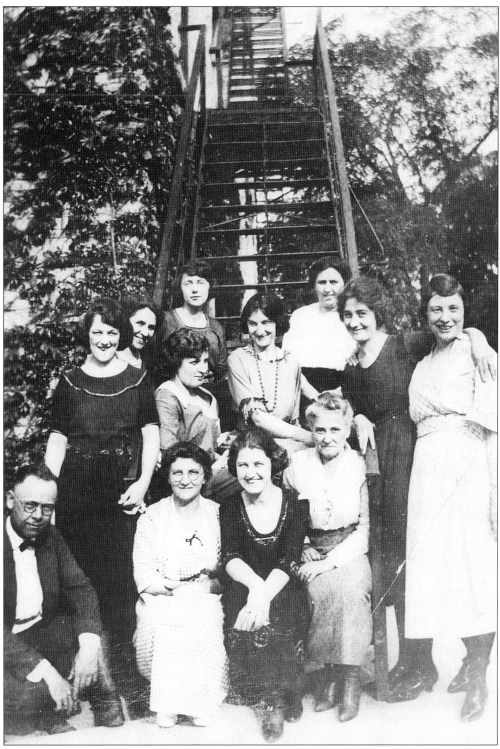

This picture shows the teachers who worked at Central Grade School in the early 1920s. The fire escape was located on the west side of the building.

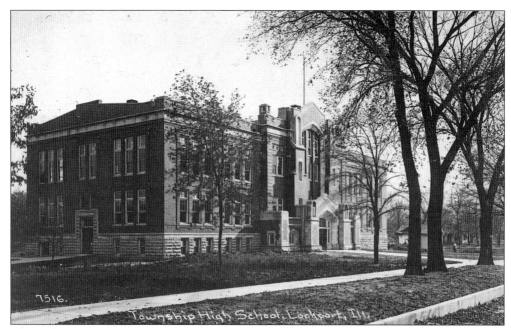

The high school, now called Central High School, is shown here as it appeared when it opened in 1910. There were many additions made to this building in later years.

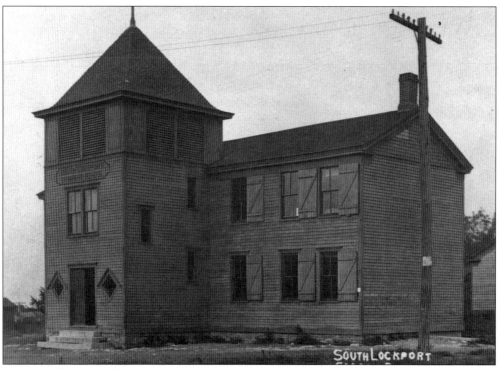

South Lockport Grade School, shown here c. 1897, was replaced by a brick structure and renamed Taft School in 1906. The first school was usually a wood frame structure.

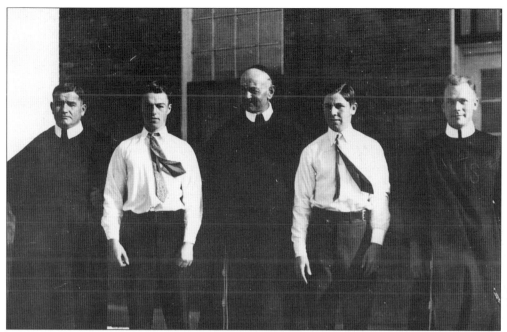

These students were photographed at Lewis University *c.* 1939. The present university was established to train boys in manual arts in 1932, but soon became a training school for aviation and airplane repair. It was established by Bishop Shield of Chicago and financially supported by Frank J. Lewis as a tuition-free school for under-privileged Chicago boys. It still offers an aviation curriculum but has expanded to include a traditional four-year liberal arts degree and five graduate programs. In this picture, the clerics were Franciscan brothers. The university is now a Christian Brothers establishment.

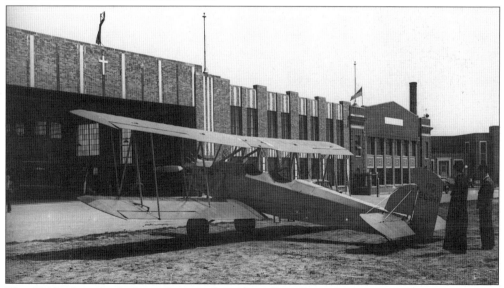

This 1940s photograph shows the main hangar at the college. By this time, the institution was a four-year college and no longer offered free tuition. The aviation program was still the most important part of the curriculum. This building is no longer an airplane hangar; it has been redesigned and is presently the Philip Lynch Theatre.

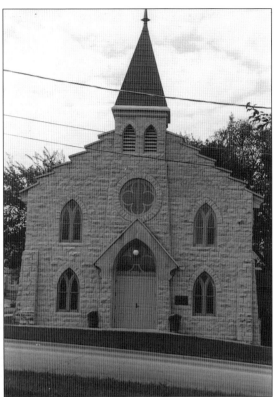

This is the former Congregational church in Lockport. Built in 1840, it is the oldest church building in Lockport, and probably, the oldest masonry church building in Illinois. It was designed by James Baker in the Greek Revival style. In 1888, due to storm damage, the wooden Greek Revival portico was replaced by this Gothic-revival stone front. Presently the Gladys Fox Museum, it houses traveling historic and art exhibits.

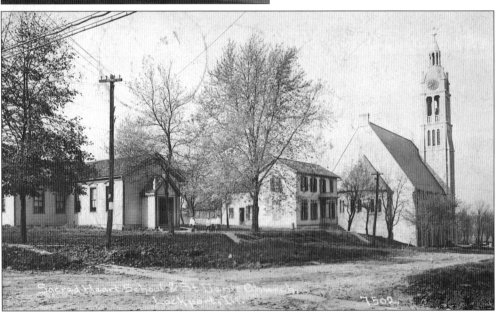

St. Dennis Catholic Church was established in 1846 by Father Dennis Ryan to serve the Irish canal workers. The original church is the frame building on the left. It was moved from a canal work camp called Haytown that was located north of Lockport. When the stone church was built, the old church became St. Dennis School. The building in the center of the picture served as the convent for the nuns who taught at the school. The last two buildings are gone.

St. Dennis Church, shown here *c.* 1909, was completed in 1879. It was designed by the Chicago architects Eagen and Hill. In 1965, it was hit by a tornado and necessitated modifications of the tower and the rose window in the west façade.

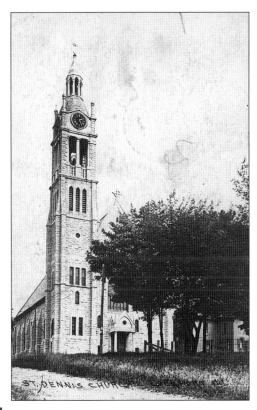

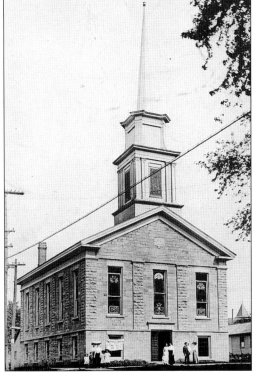

The Methodist church was the second one built for that denomination. This local limestone building was built in 1854. The Greek Revival wooden tower is now gone, and the building has been divided into three floors. When this photo was taken *c.* 1910, there were only two floors.

St. Joseph's Catholic Church was built in 1874. The congregation at that time was mostly German, whereas the congregation at St. Dennis was largely Irish.

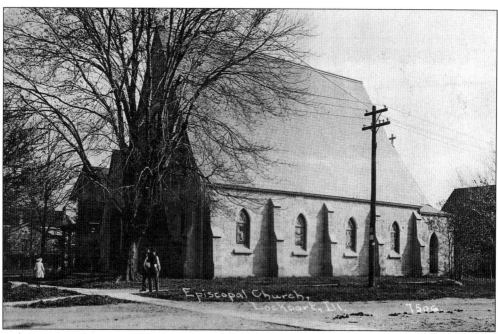

St. John's Episcopal Church was designed by P.N. Hartwell in the English Gothic Revival style and was built in 1873. Though badly damaged by fire in the early part of this century, it still remains one of the most impressive Gothic Revival churches in the area.

The Swedish Lutheran Church was built in 1906 to serve the most recent immigrant group, who settled on the south side of Lockport, where this frame church is located.

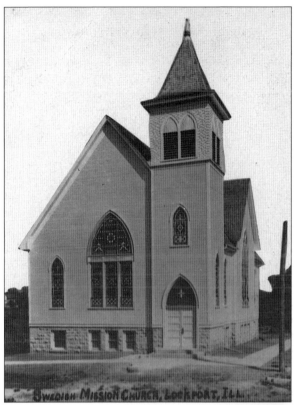

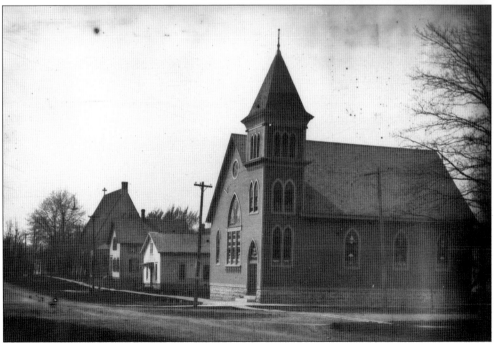

This is a c. 1900 view of the former Evangelical Association Church. When the parish was dissolved in the 1920s, this building was torn down. Much of the lot remains vacant.

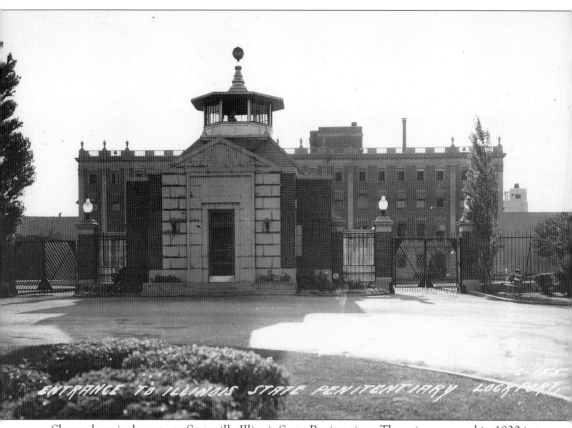

ENTRANCE TO ILLINOIS STATE PENITENTIARY LOCKPORT

Shown here is the gate to Stateville Illinois State Penitentiary. The prison opened in 1920 just west of Lockport. Its circular cell blocks were presumed to be a new prison concept, but the idea was actually first proposed by Jeremy Benthan in 1791. He called it a "panopticon," which means "all seeing." Prisoners could be observed at all times by a guard located at the center of the cell block. The cell blocks and the prison walls, the largest in the U.S. at the time, were made of poured concrete.

Five

DOWNTOWN

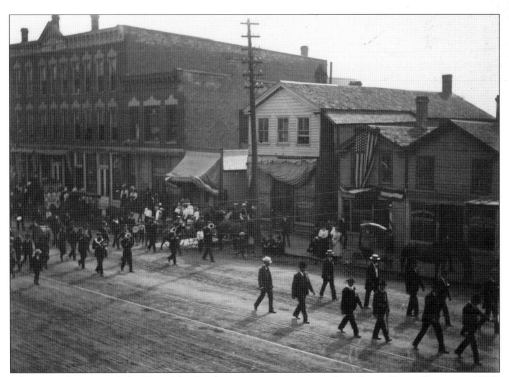

The Grand Army of the Republic Lockport contingent marches down State Street *c.* 1896. The downtown was the center of civic life in Lockport. It was not only the scene of parades but the public place where the citizens came to shop, to walk, and to gape. Since the downtown's historic integrity was intact and its importance to the town so great, it was placed on the National Register of Historic Places in 1975.

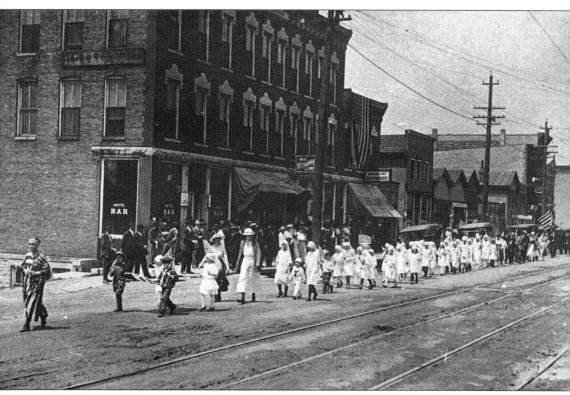

Another patriotic parade hails the end of World War I in this 1918 view. There are two tracks for the interurban shown here. The interurban could take you to Chicago or Joliet every hour, except at night.

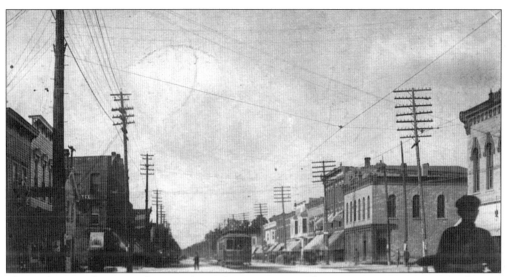

Shown here is the interurban on State Street *c.* 1909. The most prominent pieces of street "furniture" were the electric poles.

This is the same scene, photographed *c.* 1960. The electric utility poles have disappeared and the street is now completely occupied by automobiles. The interurban street car tracks are buried under the asphalt.

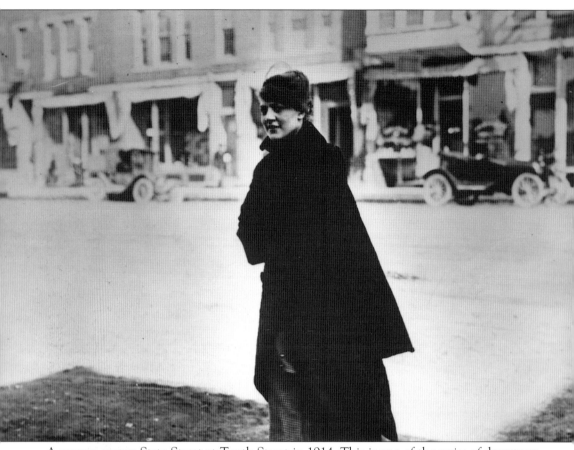

A woman crosses State Street at Tenth Street in 1914. This is one of the series of downtown scenes photographed by H.H. Carter, a local pharmacist and amateur photographer.

This 1944 photograph shows the municipal water tower located on Tenth Street.

This 1940s view shows the fire station that was once located in the city hall. The fire department abandoned the downtown area in the 1960s, and, in the 1980s, city offices were moved into Central Square. The building then housed the police department. It was abandoned in 1997.

A Lockport fire truck is parked in front of the State Street buildings, across from the former fire station.

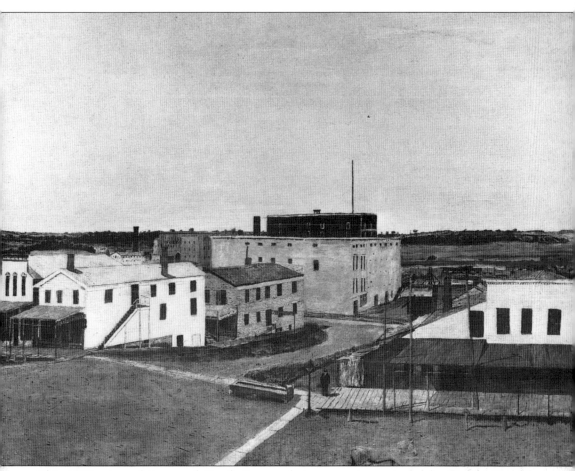

This 1880s view of State and Tenth Streets, facing west, is a painting by Styx McDonald (1829–1916). Copies of McDonald's surviving paintings can be viewed at the Gaylord Building. He also wrote books on philosophy and the occult, and worked as a newspaper publisher and editor in Lockport.

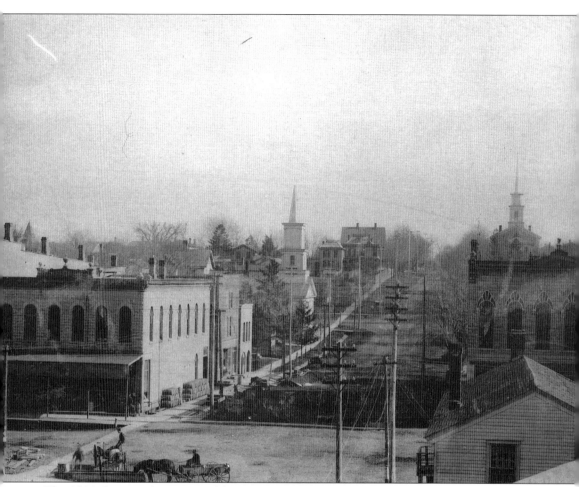

This 1891 photograph is a view of the corner of State and Tenth Streets looking west. The horse trough that McDonald painted was still there when this photograph was taken. The nearest steeple was on the Baptist church; it has been removed. The building is now an ice cream parlor. At the top of the hill is the Methodist church, which also has its steeple in place.

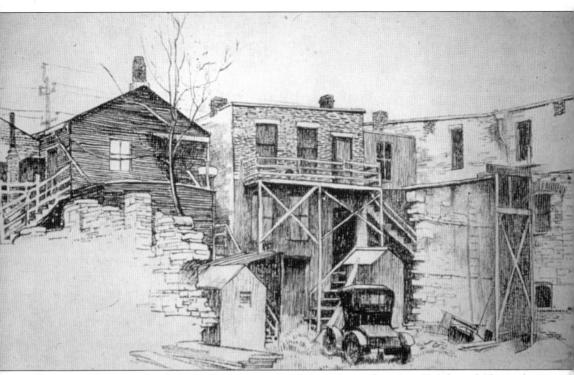

This is a 1920s sketch of the back or west side of State Street between Tenth and Eleventh Streets. It was drawn by John Norton, an artist from Lockport. The stone wall remnants on the left indicate that, before the 1870s double tracking by the railroad, buildings were built to the edge of Commerce Street, which was originally a major retail and manufacturing street.

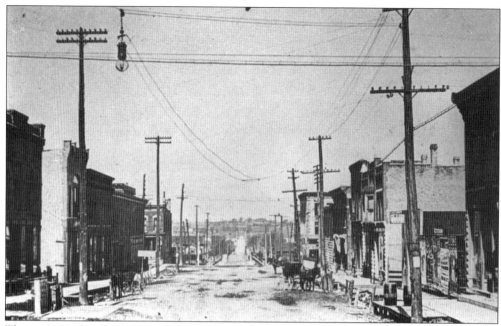

This *c.* 1898 photo is a view of Ninth Street, looking across State Street and the Illinois and Michigan Canal.

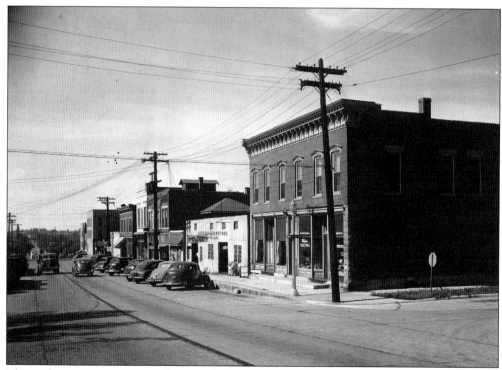

This is the same street scene, photographed in the early 1940s. The automobile has completely replaced the horse, so the street is paved. The electric utility poles are still present.

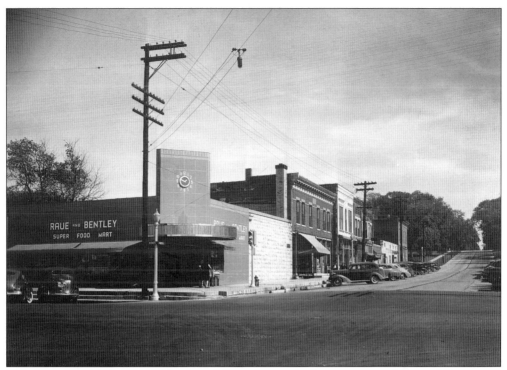

This is an early 1940s view of Ninth and State Streets, looking east toward Central Square.

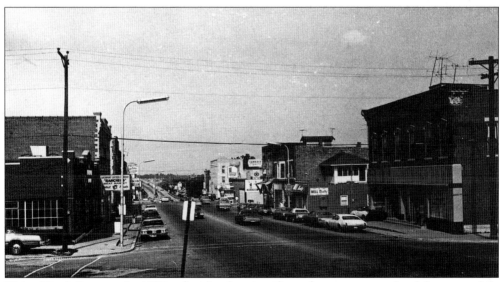

This is Ninth Street in the 1970s, after the electric utility poles were removed and the automobile had moved in to completely dominate the scene.

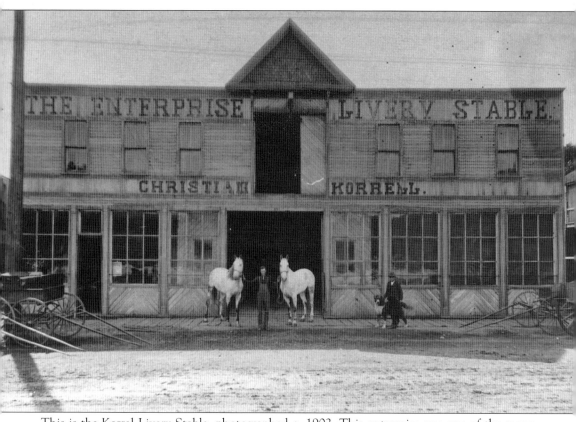

This is the Korrel Livery Stable, photographed *c.* 1902. This enterprise was one of the many livery stables downtown. It was converted to a garage in the 1920s. Next to it, on the left, is a blacksmith shop that has since disappeared.

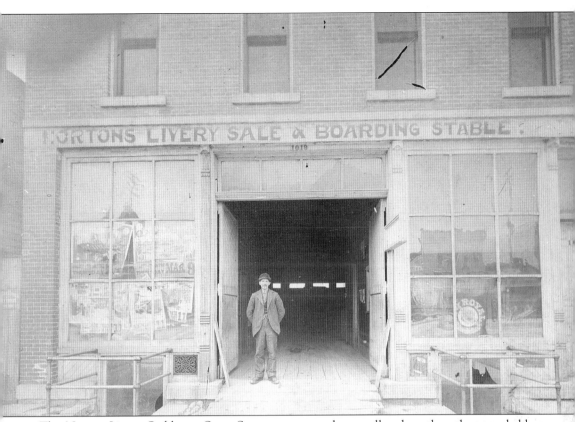

The Norton Livery Stable on State Street was somewhat smaller than the others, probably because it was located where the Roxy movie theatre was, in the heart of the downtown.

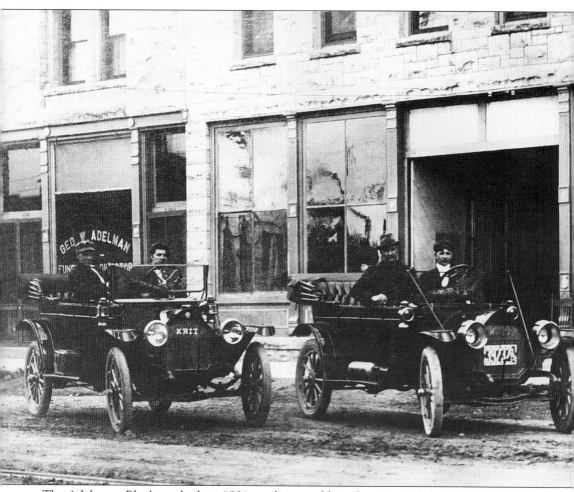

The Adelmann Block was built in 1891 as a livery stable and a store on the corner of Eleventh and State Streets. It was converted to an automobile garage and auto sales facility.

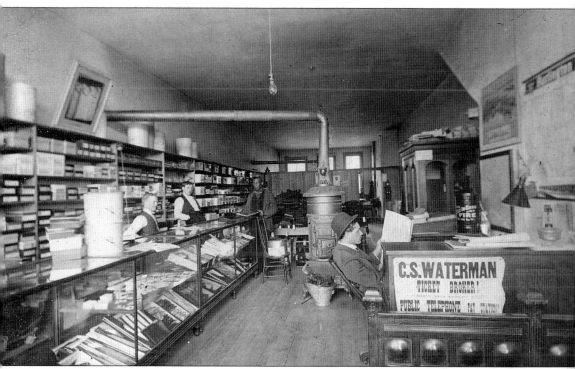

This is an interior view of Waterman's ticket office and haberdashery. It was located on State Street and sold tickets for the interurban, the railroad, and various theatrical performances. At the time this picture was taken, they also sold men's clothing. It later sold cigars and tobacco.

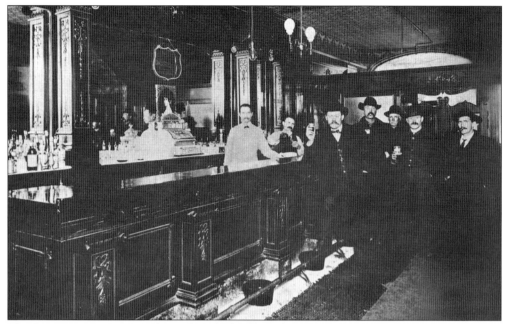

This bar on State Street was located in the building that is presently occupied by the Tall Grass Restaurant, a well-known gourmet eatery. This picture was taken c. 1902.

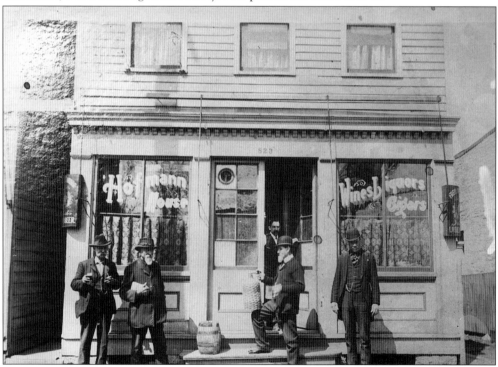

Another bar or saloon, then known as the Hofmann House, still dispenses spirits, though the facade has changed as well as the name. The barkeeper is keeping a wary eye on those patrons drinking on the street. Lockport, around this time (c. 1900), was famous for the number of bars downtown. Today, although somewhat diminished, they are still very much in evidence.

Six

HOMES AND FARMS

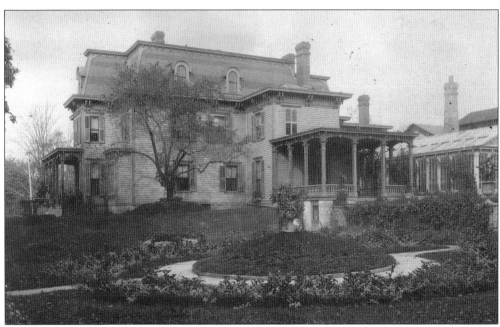

This house was built by John L. Norton. The son of Hiram Norton, he inherited the profitable flour mill, grain warehouse on the I and M Canal, and an elevator in Chicago, as well as other resources. The grounds were extensive; they included a greenhouse and a large formal garden. The grain business went bankrupt in 1897, due to Norton's over expansion and the decline of trade on the Illinois and Michigan Canal. The house and part of the gardens with its iron fence still stand on the corner of Hamilton Street and Eleventh. The house was built in the 1880s.

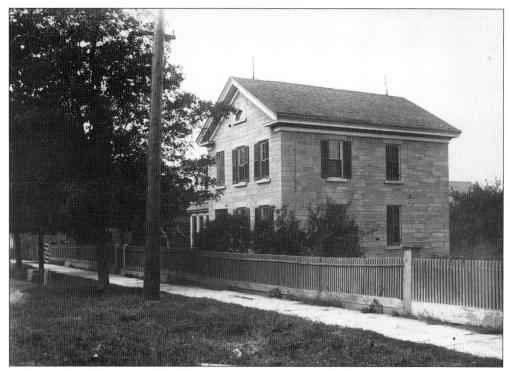

This is a view of the Julius Schiebe home on State Street. Schiebe was a master stone mason who built and designed many of Lockport's stone buildings. This particular building, which was constructed in the 1850s in the then popular Greek Revival style, is still located on State Street.

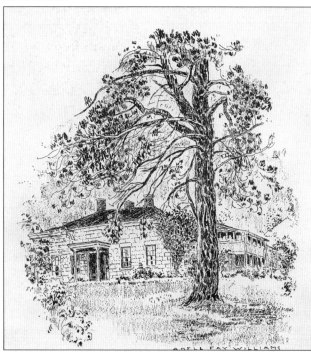

The Milne house on Eighth Street was built by Robert Milne, who came from Scotland to Lockport. It was here that he contracted to build locks on the Illinois and Michigan Canal. He owned a large farm near this house, and he was one of the first breeders to bring Short Horn cattle to this country. He was closely associated with the I and M Canal after its completion; he served as both the treasurer and the collector of tolls. This drawing of the Milne House was rendered by Adele Faye Williams, who, in the 1920s and 1930s made sketches of many historic sites in Lockport and Joliet.

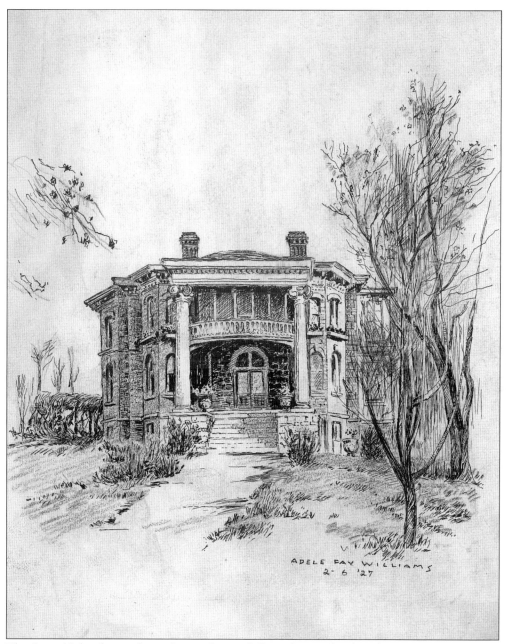

The Isaac Nobes house formerly stood on a hill to the south of Lockport, on State Street. Nobes was born in Wales in 1822 and served in the British Navy before coming to Lockport in 1848. He helped build the "General Fry," the first boat to navigate the canal from Lockport to Chicago in April 1848. He continued to work as a boat builder until he went into the quarrying business. He prospered as can be seen from this magnificent building that over-looked his Oak Hill Quarries. It was said to be the most expensive home in Lockport when it was built in 1874. The period from 1865 to 1910 was the great period of stone quarrying in Lockport and Joliet. This pen-and-ink drawing is by Adele Faye Williams.

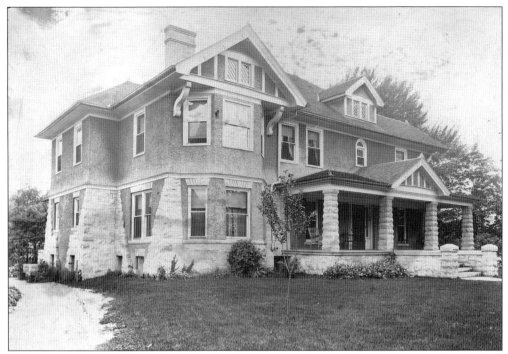

This is the Leon McDonald house, which was built in 1904 and designed by C. Webster, a Joliet architect. Its walls are of poured concrete, the first use of that construction method in Lockport. McDonald was a newspaper publisher and the superintendent of the I and M Canal between 1890 and his death in 1914. He was also mayor of Lockport when the great fire of 1895 broke out. His father, Styx McDonald, the painter and philosopher, lived in this house also until his death in 1916.

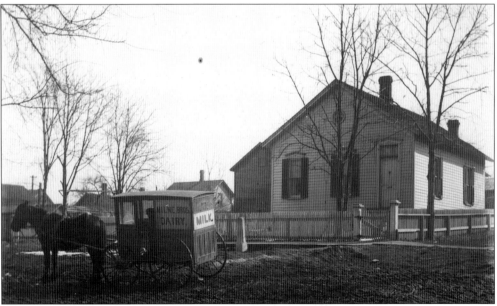

Besides the great houses, there were a large number of humbler dwellings such as this one, whose morning milk is being delivered. The milk was from the Milne Dairy of Robert Milne.

This frame house is now gone. It shows how Lockport houses were changed over time. It was probably built in the 1860s in the Greek Revival style. In the late 19th century, when the Second Empire style came in, the mansard roof with its dormer windows was added. Stylistic fashion sometimes breeds strange but attractive combinations.

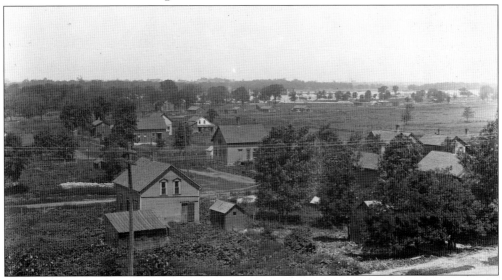

This is a view of the homes on the west side of the I and M Canal, which can be seen in the foreground. The Des Plaines River can be seen in the distance. The photo was taken before 1893, as the scene would be much changed after the Ship and Sanitary Canal was built between 1894 and 1900.

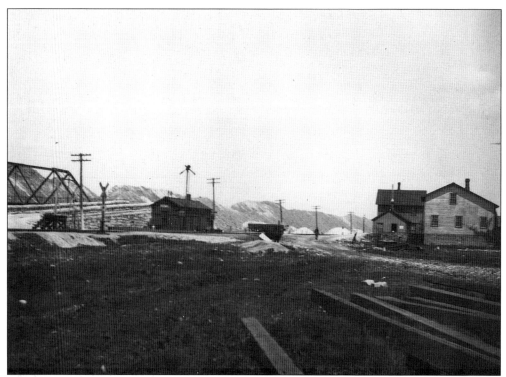

This is a view of 135th Street, north of Lockport. Here can be seen some of the houses in the original Romeoville. The Santa Fe Railroad and the Ship and Sanitary Canal's 135th Street swing bridge can be seen on the left. The Sanitary Canal was probably under construction when this photo was taken c. 1900.

This English-style cottage was built by Mary Walker and her husband, Harry Walker, in the 1930s. It is of note that the stone used to build the house, the garage, and the stone wall came from the stone fences of farms that were being bought up in 1940 by the U.S. Army for its Joliet Arsenal. These fences were reportedly erected during the Civil War by Confederate Army prisoners.

96

Pictured at right is the interior of a typical corn crib c. 1920. This was a part of the Fitzpatrick farm, located west of Lockport where Lewis University is now. It was owned by the Hensel family, who rented from the Fitzpatricks.

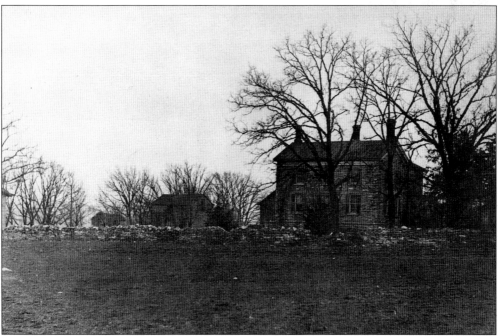

This view is of the Fitzpatrick farm c. 1910. This stone farmhouse was built by Patrick Fitzpatrick, who came to the site in 1834 after emigrating from Ireland to this country through Canada. He was a prosperous farmer and was much involved in affairs of Lockport. The building is now owned by the State of Illinois and houses the offices of the Illinois and Michigan Canal National Heritage Corridor Commission.

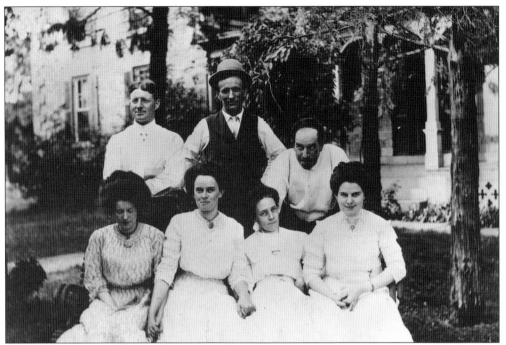

These people worked on the Fitzpatricks' farm c. 1910. The front of the house is seen in the background.

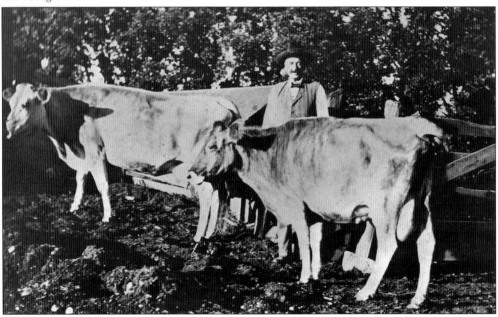

Michael Fitzpatrick (pictured) was the only son of Patrick Fitzpatrick, who died in 1888. The farming done here in the latter part of the 19th century and the early 20th century was mainly raising livestock, cattle, and sheep. Butter, also manufactured here, was shipped to Chicago on the early morning milk train. Michael Fitzpatrick never married. One of his two sisters married but there were no children. Much of the Fitzpatrick farm was later given to the new Lewis College. The stone house is located across the road from the Lewis University Campus.

Seven

Fire, Flood, and Festivals

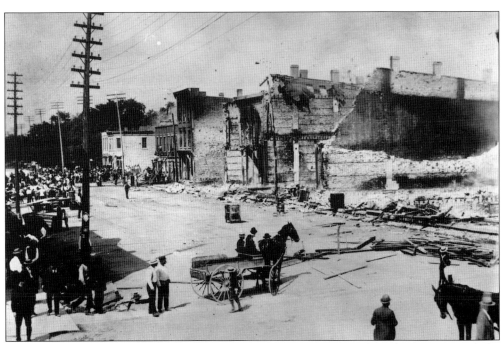

In August 1895, a fire broke out in downtown Lockport. It was a hot, dry summer and the flames quickly spread, pushed by a strong south wind, and engulfed the east side of State Street. The fire moved faster than a man could run, moving east on Ninth Street and continuing half a block to engulf and destroy the stone school on Central Square. This picture shows the destruction on the east side of State Street.

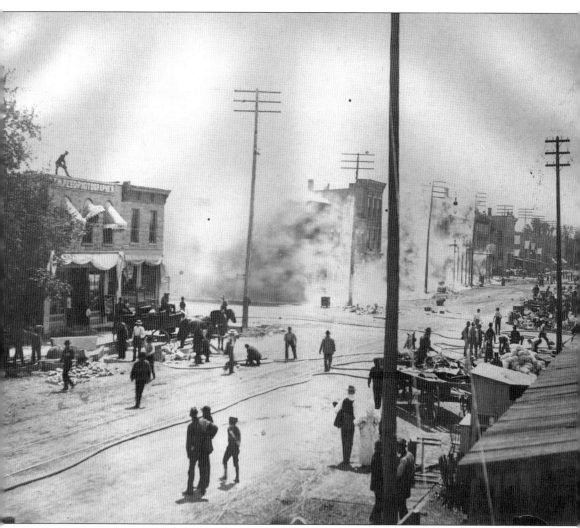

This is another view of the destructive fire of August 10, 1895. In this picture, we are looking south. Many feared that the conflagration would spread north of Ninth Street and destroy the residential area because the town lacked a pumper or a water supply to fight the flames. A telegram to Chicago and an express train, however, prompted the delivery of a pumper. This steam-driven device pumped water from the canal to save the city. The photographic shop (far right) was saved, and the photographer, Reed, was able to record the disaster.

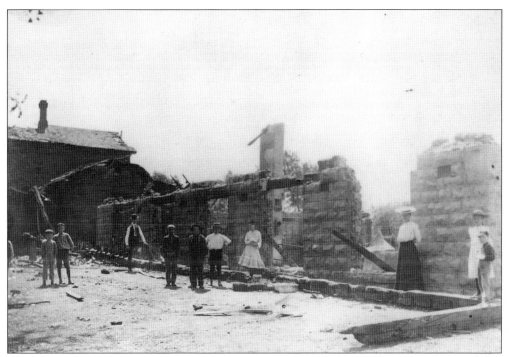

This photo shows the damage done to one structure. Thankfully, no lives were lost, and the downtown was quickly rebuilt. Many of the buildings were originally made of stone, but they were rebuilt with brick facades by 1896. The only exception was Central School, which was rebuilt with local limestone in the Richardson Romanesque style that was popular in the late 19th century.

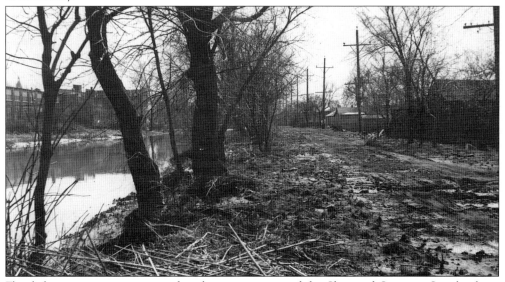

Floods become more common after the construction of the Ship and Sanitary Canal, whose banks intercepted the natural flow of the canal and the streams flowing into it. These floods have been particularly hard on the residents living on the west side of the I and M Canal. This view of the canal, looking south during the flood of 1947, shows the soggy condition of Canal Street after the flood receded.

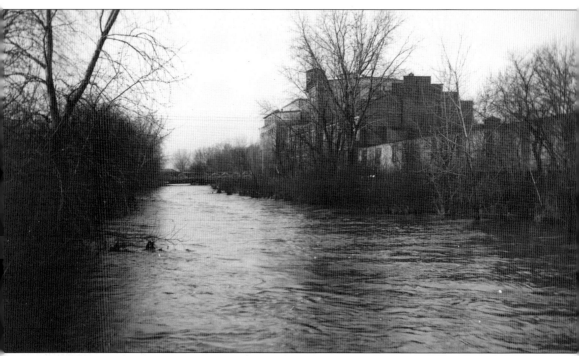

This view, looking north, shows the 1947 flood's impact on the I and M Canal. On the right is the Norton building.

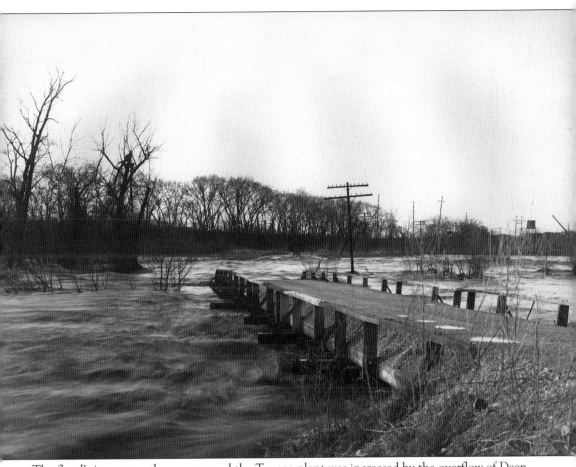

The flood's impact on the area around the Texaco plant was increased by the overflow of Deep Run Creek. This waterway is located in the bed of the old Des Plaines River. The river itself was shoved west when the Sanitary and Ship Canal was built. This interrupted the natural flow in Lockport, creating flood plains where none had existed before.

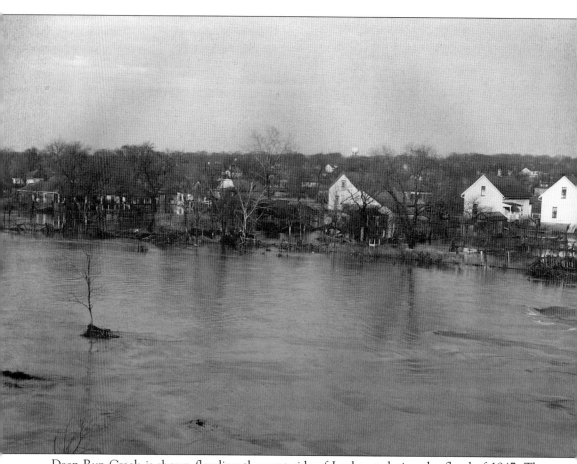

Deep Run Creek is shown flooding the west side of Lockport during the flood of 1947. The photograph was taken from the high bank of the Sanitary and Ship Canal, facing east.

Pictured is a scene from the Old Canal Days parade in 1976. This historic festival began in 1972 to celebrate Lockport's canal heritage. It occurs the third weekend in June and is kicked off by a parade on Friday night. This one celebrated the town's bicentennial.

In 1978, the Old Canal Days festival was held at the Pioneer Settlement of the Will County Historical Society. In this area, on the banks of the canal, log cabins and other structures from the pioneer days have been collected and erected. During Old Canal Days, the lifestyle of those pioneers is recreated.

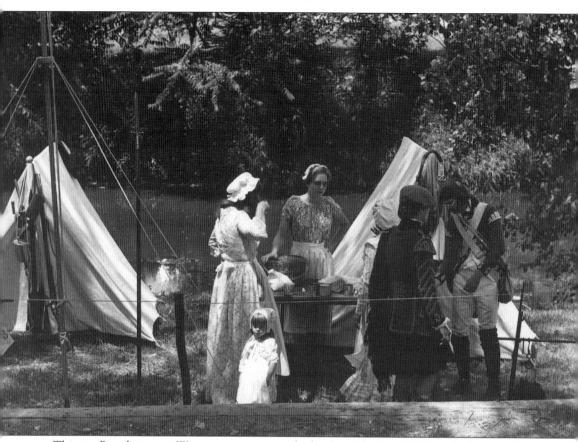

This is a Revolutionary War encampment on the banks of the I and M Canal, photographed in 1976. One of the features of Old Canal Days is the re-enactment of former wars. The actors set up their encampment along the canal; they often recreate Civil War scenes, but in the 1970s, Revolutionary War uniforms were more the style.

Eight

LOCAL WRITERS AND ARTISTS

John L. Norton (1876–1934), the grandson of Hiram Norton, always aspired to be an artist. Circumstances, however, conspired to create difficulties. He started out at Harvard but the bankruptcy of the Norton firm in 1897 forced him to drop out. He went to the Chicago Art Institute School of Art and, for most of the rest of his life, was associated with that institution.

He became a well-known painter and built his studio in Lockport, on his family's grounds; this studio still exists. He also worked as a teacher and a painter of public murals. There are a number of the murals still existing in Alabama, St. Paul, and Chicago.

This is one of John Norton's lithograph of St. John's Episcopal Church in Lockport. He created a number of Lockport scenes, but many of them have been lost.

Edward Worst (1866–1949) was a teacher whose concept of education was based upon working with your hands, particularly weaving. He was a well-known weaver who designed looms and wrote books about weaving. He taught weaving in the Chicago Public Schools and in the summer at Pennland in North Carolina. He was a great advocate of teaching people to overcome mental difficulties by using their hands. He also worked with prisoners at the State Penitentiary to regain their self-respect by creating with their hands.

One of Worst's public projects was a spinning and weaving cooperative in Lockport. He brought together a number of women who were immigrants from Sweden to weave and spin for the Lockport Cottage Industries. They experimented with planting and processing flax, which was then spun and woven. The spinner in this picture is Mrs. Allard. The napkins and other products were sold in stores in Chicago.

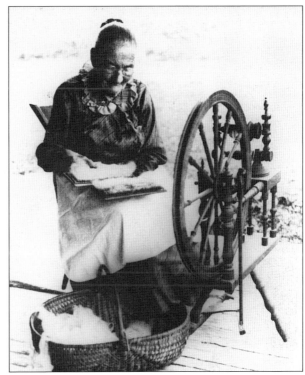

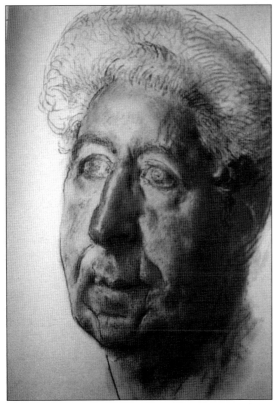

Sharmel Iris (1889–1967) was a Chicago poet who was the poet in residence at Lewis University from 1950 until his death. He was one of the original Chicago poets published in Harriet Munroe's *The New Poetry Anthology* in 1917. He published much of his work in *Poetry Magazine* and other publications, and he wrote five volumes of verse. The first, published in 1914, was called *Lyrics of a Lad;* the last three, he published while at Lewis University. He was mentioned in one of F. Scott Fitzgerald's novels and was acquainted with a number of prominent artists, including Diego Rivera, Augustus John, and Salvador Dali, who did his portrait.

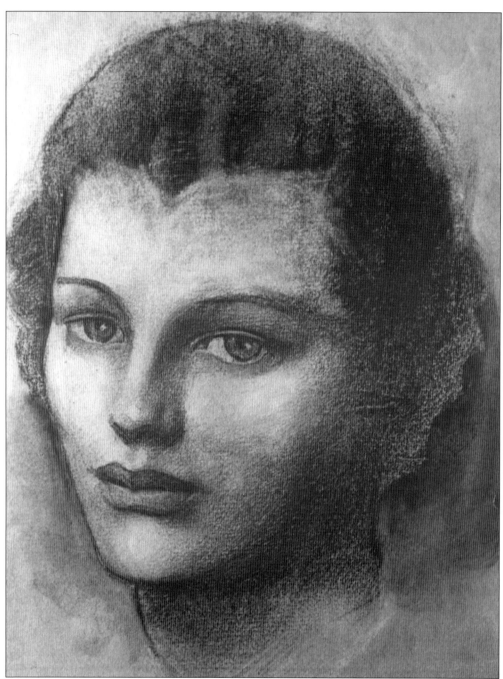

Dorothy Dow Fitzgerald (1898–1989) was born in Lockport. She was a poet and writer closely associated with John Norton, the artist who made this portrait. She was a close friend of Edgar Lee Masters, who encouraged her in her writing. Her last published poem called "Shake Lockport Out of the Box" was published in the Lockport legacy, *Studies on the Illinois and Michigan Canal Corridor* in 1990. Fitzgerald wrote novels, three volumes of poetry, a play, and a biography of Edgar Allen Poe. She, like Norton and Iris, was an important part of the Chicago artistic life that flourished in the 1920s and the 1930s.

Nine

A Nineteenth-Century Family at Home

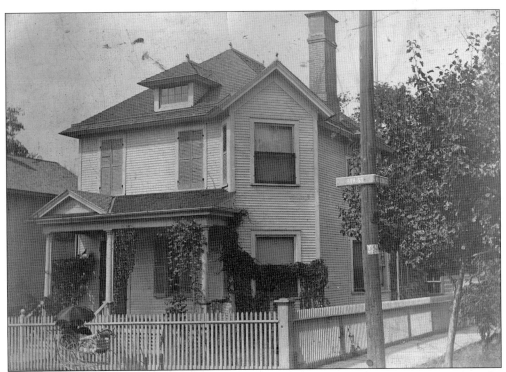

The Deeming house, shown here c. 1897, was built c. 1891 by Arthur Deeming. It was the first house owned by the Deeming family. On the following pages, the pictorial history of this family—the story of a family at home—is displayed over the course of three generations.

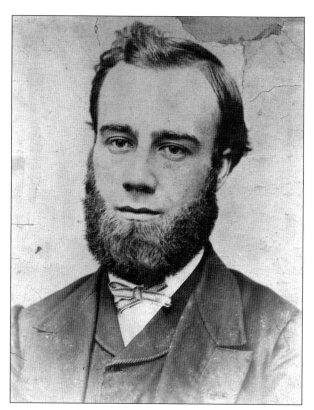

Arthur Deeming (1843–1931) is shown here in the 1860s. He came to Lockport in 1855 as a young man, fresh off the boat from England, and found employment as a carpenter at the canal boat yard on Fourth Street. This boat yard, one of two in Lockport, produced five or six barges a year for use on the canal. Most of their business was caulking and repairing boats already in use.

Hiram Norton talked to the young Deeming and, impressed by his work ethic and opposition to slavery, hired him to work at the Norton Grain Warehouse.

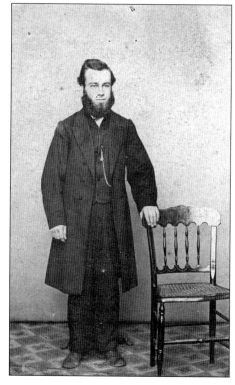

This photograph shows Arthur Deeming c. 1871, by which time he was married. He first lived inside the Norton Grain Warehouse, on the second floor of the east wing. At night, he guarded the safe in the office on the first floor, watching through a hole that had been cut in the floor. Hiram Norton also asked him to judge the winner in canal boat races from the warehouse to Chicago. In those days, when mules were used to haul the boats, it was important to get to the Chicago market when prices were right. Deeming was forced to deal with irate canal boat captains who tried to cheat on their time. He knew what to expect from the boats; he was in charge of keeping track of Norton's five.

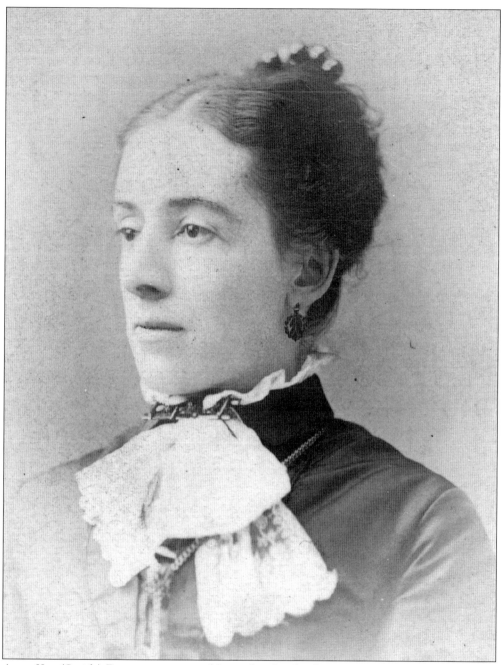

Anna Kay (Smith) Deeming is pictured here, shortly after her marriage to Arthur. Anna Kay Deeming's first memory was wandering all alone, a child on the streets of Chicago. She had no idea where she came from or who her parents were. She was taken in by a kind minister and came to Lockport as a maid to the pastor of the Baptist church. Arthur Deeming found her sleeping on a bench in the pastor's hall. He took her out of that servitude and eventually married her. Whatever her origins, she was a natural musician and was placed in charge of music for the Methodist church. She would pass this talent on to her daughter. This photograph was made by R.R. Richards, a long time photographer in Lockport.

May Deeming, shown here *c.* 1869, was the only child of Arthur and Anna Kay Deeming. This photo was taken by L.H. Whitson, who was a Lockport photographer from 1867 to 1875. Photographers, in the early days of the wet plate process, seemed to stay in one place for only a few years. Whitson was one of the earliest—maybe the first—photographers in Lockport.

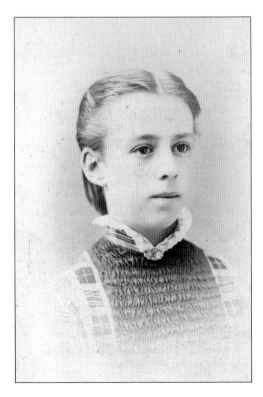

This is May Deeming at age 12, photographed *c.* 1881.

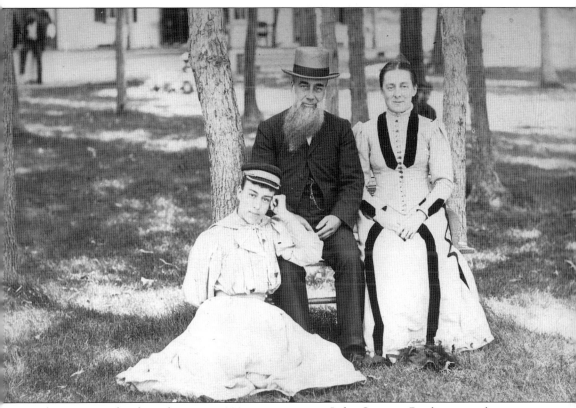

The Deeming family is shown in 1892, vacationing at Lake Geneva. By this time, they were firmly established in the house on Eighth Street. They must have visited to Lake Geneva every year; they had a number of pictures taken there.

May Deeming poses with two of her friends, one of whom is dressed as a man. They appear to be enacting a melodrama with the evil Whipsnade wearing a fake mustache.

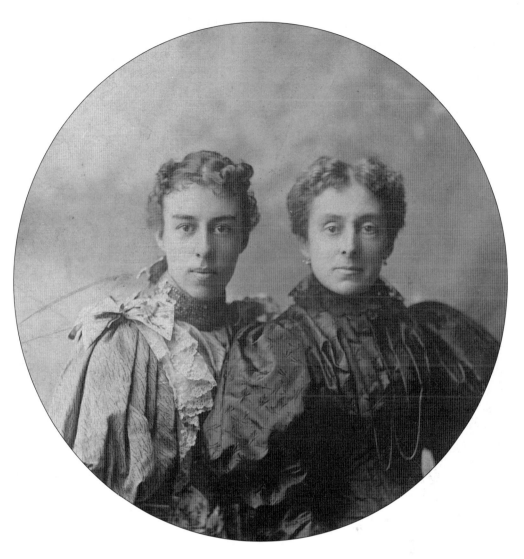

May and Anna Kay Deeming are shown here in June 1896.

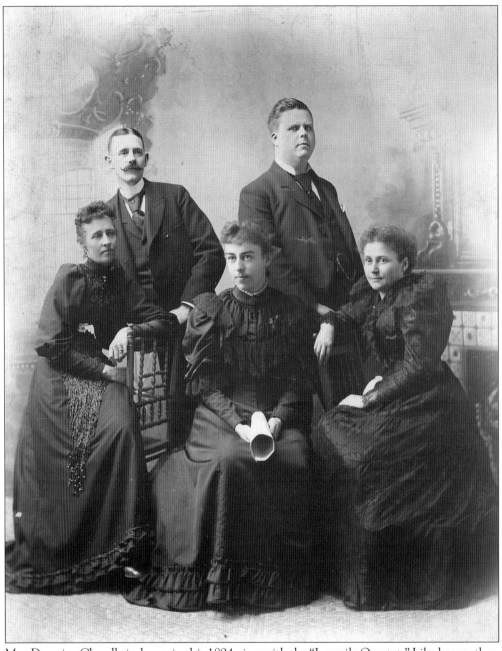

May Deeming Cheadle is shown in this 1894 view with the "Juvenile Quartet." Like her mother, she was a natural musician. The tall, overly serious looking man is Leon McDonald, mayor and canal superintendent. He was reported to have a fine tenor voice. At this time, May was married to Tom Cheadle.

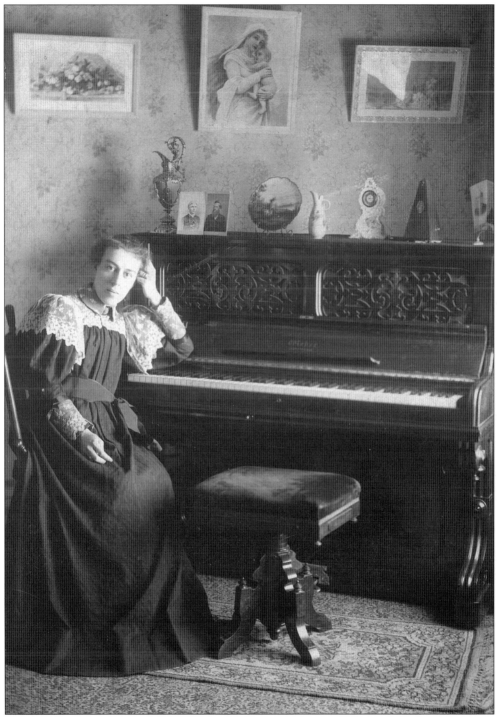

May Deeming Cheadle is pictured by the piano at the house on Eighth Street in this photograph from c. 1896. The decorations are typical of the 19th-century parlor. The photographs on top of the piano (far right) are views of her parents, Arthur and Anna Kay, shown earlier in this section.

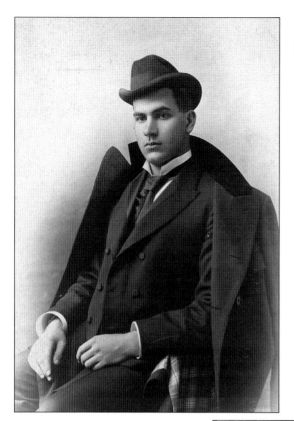

Thomas Cheadle is shown in this 1895 photograph, shortly after his marriage to May Deeming. After his marriage, the couple came to live in the house on Eighth Street.

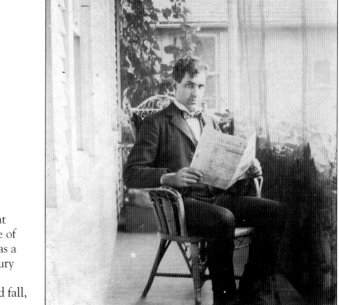

Thomas Cheadle reads his morning paper on the porch at Eighth Street. The porch, one of two at the Deeming house, was a common feature of 19th century residences. They weren't just decorative; in the summer and fall, they served as family rooms.

Thomas Cheadle and his son, Arthur Cheadle, are seated on the front porch of the house on Eighth Street. The railing was a handy place to sit, and it was important to be photographed in the outdoor light. The Cheadles would have three children, Arthur, Bruce, and Anna Mae.

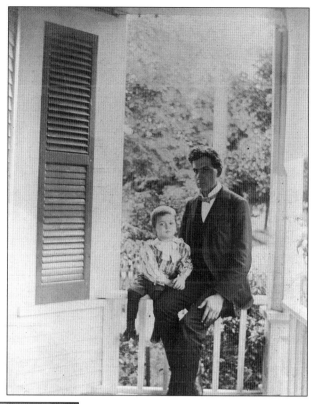

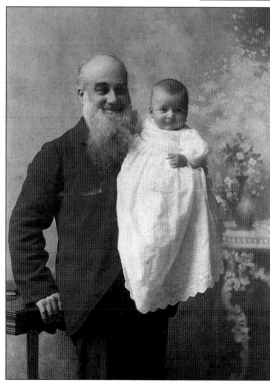

Arthur Deeming is shown with his grandchild, Bruce Cheadle, in November 1897. Bruce is the baby in the buggy depicted in the photo of the Deeming Cheadle house on page 111.

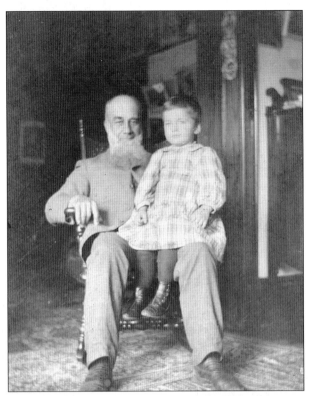

This is a view of Arthur Deeming with his other grandson Arthur in their living room.

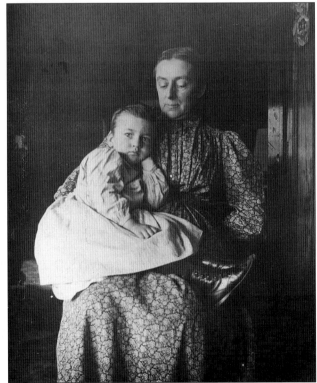

Anna Kay Deeming and Bruce Cheadle pose in the dining room, c. 1900. Both boys are wearing dresses, which was common for young boys in those days.

In this *c.* 1901 photograph, Grandpa Deeming crosses the street in front of their house with his two grandsons, Arthur and Bruce Cheadle. Bruce is the one in the dress. Arthur Deeming left the Norton firm after it went bankrupt in 1897. He then went into newspaper publishing, working with the *Will County Advertiser* and other papers. Thomas Cheadle, his son-in-law, was his associate in the business.

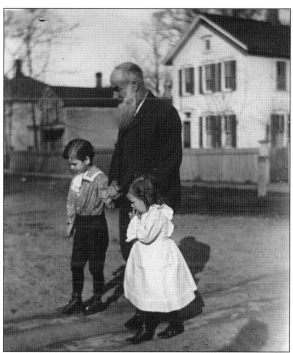

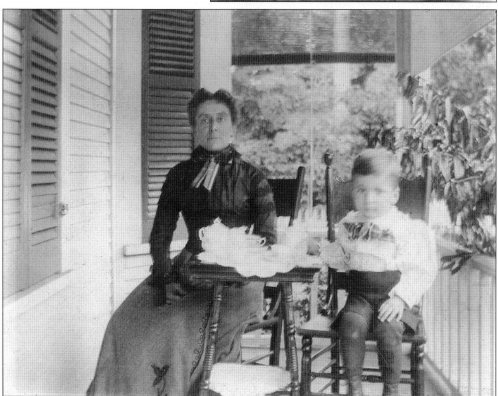

Anna Kay Deeming and Bruce Cheadle have tea on their front porch. Bruce grew out of the dress and is wearing knee britches.

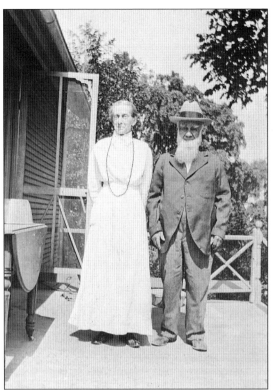

Arthur and Anna Kay Deeming pose on their back porch c. 1918.

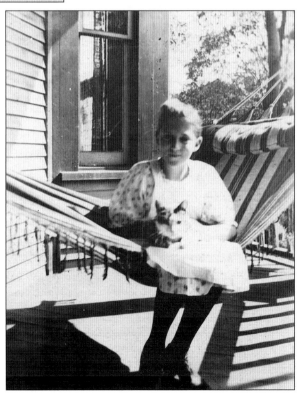

Anna May Cheadle is shown with her pet cat on the front porch in 1918.

Anna May Cheadle is shown here in 1922. She died a year later.

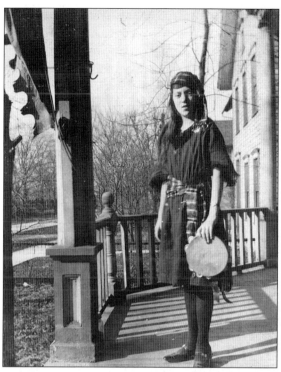

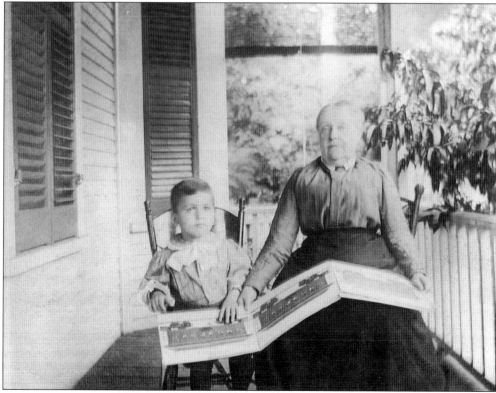

Bruce Cheadle and his baby sitter, Miss Jennings, read on the front porch.

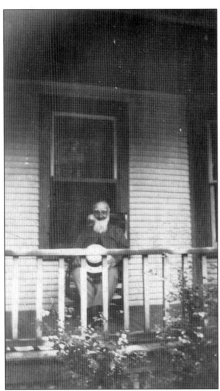

Arthur Deeming is shown on the front porch, c. 1930.

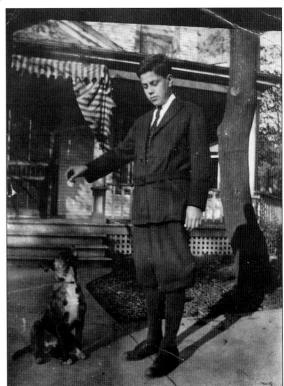

In this c. 1918 view, Arthur Cheadle plays with Bobby, the family dog.

Bruce Cheadle digs in the back yard of his house, *c.* 1900.

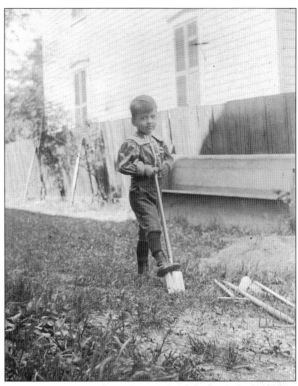

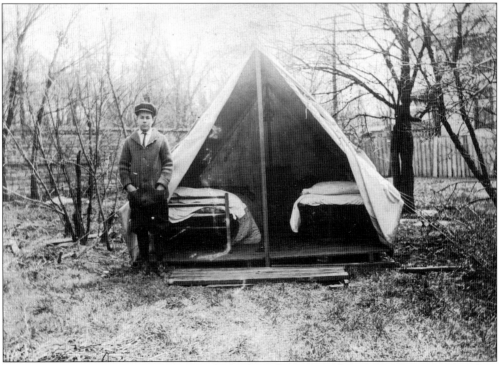

Bruce Cheadle camps out in his tent in the back yard, *c.* 1920. There are no surviving members of the Deeming-Cheadle line today.

BIBLIOGRAPHY

History of Will County. Wm. Le Baron Company, Chicago, 1878. (This work is sometimes referred to as the Woodruff History, as George Woodruff wrote a part of the work.)

Souvenir of Settlement and Progress of Will County Illinois. Chicago, 1984.

Genealogical and Biographical Record of Kendall and Will Counties Illinois. Biographical Publishing Company, Chicago, 1901.

Proceedings of the Darling Reunion Held at the Norton Opera House Lockport, Illinois. Lockport, Illinois, 1901.

Lockport Illinois Past, Present, and Future. Lockport Woman's, Lockport, Illinois, 1905.

Stevens, W.W. *Past and Present of Will County.* 2 volumes, Chicago, 1917.

Cheadle, Bruce. *Lockport Has a Birthday.* Lockport Centennial Committee, Lockport, 1930.

Cheadle, B. and P. Simonsen. *Lockport, Illinois, Historic Canal Town.* Bloomington, Illinois, 1975.

Lockport, Illinois, A Historic District Preservation Plan. Preservation, Urban Design Inc., Ann Arbor, Michigan, 1977.

Lockport, Illinois, an HCRS Project Report. U.S. Dept. of the Interior, U.S. Government Printing Office, Washington, D.C., 1979.

Lockport, Illinois: A Collective Heritage. Bank of Lockport, Linda Legner, compiler, Lockport, Illinois, 1980.

Cheadle, B. *Hail and Farewell.* Civic and Commerce Association. Lockport, 1980.

Ingalls, M., V. Noble, and R. Trovato. *Excavations at the John Marx Tannery.* Midwestern Archeological Research Center, Bloomington, Illinois, 1984.

Philippe, J.S. *Archeological Investigation at the Gaylord Building, Lockport, Illinois.* Midwestern Archeological Center, Normal, Illinois, 1986.

Garner, John S. *The Fitzpatrick Homestead.* University of Illinois School of Architecture, Urbana, Illinois, 1987.

First Congregational Church of Lockport, Illinois 1838–1988. Lockport, Illinois, 1988.

Conzen, M. ed. *Lockport Legacy: Themes in the Historical Geography of an Illinois Canal Town.* Studies on Illinois and Michigan Canal Corrido No. 4. University of Chicago, 1990.

Winters, Raymond. *A Heritage to Preserve: Historic Preservation Efforts in Lockport, Illinois.* Lockport, Illinois, 1996.

Bankroff, G.J. *A History of St. Dennis Church, Lockport, Illinois, 150 years of Faith.* Lockport, Illinois, 1996.

Crilly, N.B., comp. Selections from *Early Will County Illinois Newspapers* (*The Lockport Standard* and *The Will County Advertiser* 1877–1885). 4 volumes, Will County Genealogical Society, 1997–1998.

Lamb, J. and N. Kozial. *The Historic House and Garden, Buildings and Period Landscapes of Lockport, Illinois, 1836–1936.* Lockport, Illinois, 1998.